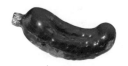

# FROM *Christmas*
## === TO ===
## TWELFTH NIGHT
## === IN ===
# SOUTHERN
# ILLINOIS

Charleston — London

THE
History
PRESS

Published by The History Press
Charleston, SC 29403
www.historypress.net

Cover design by Julie Scofield.

First published 2010

Manufactured in the United States

ISBN 978.1.59629.913.9

Library of Congress Cataloging-in-Publication Data
Dunphy, John J.
From Christmas to Twelfth Night in Southern Illinois / John J. Dunphy.
p. cm.
Includes bibliographical references.
ISBN 978-1-59629-913-9
1. Christmas--Illinois--History. 2. New Year--Illinois--History. 3. Epiphany--
Illinois--History. 4. Illinois--Social life and customs. I. Title.

GT4986.I3D86 2010
394.266309773--dc22
2010037824

*For Loretta*

# Contents

# Contents

# Introduction

I attribute my passion for folklore to two factors: my great-uncle, who possessed an Irishman's gift for storytelling, and my good fortune in being a native of the folklore cornucopia that is southern Illinois. Uncle Joe, assistant editor of the *Alton Evening Telegraph*, introduced me to the customs and beliefs of the old-time Irish and kept me regaled for hours with tales of magic and mystery. He also encouraged me to pursue writing as a career by explaining his work at the newspaper while taking me on tours of the *Telegraph*. I still remember those huge, noisy printing presses, the clacking of countless manual typewriters and desks with rotary phones that rang incessantly.

I absorbed Uncle Joe's Irish stories, as well as his accounts of local history and lore, like a sponge soaks up water. As I grew older, I began to realize the historical and cultural richness that lay beyond Alton and its stretch of the Mississippi, popularly known as the River Bend. One could follow the river south to the old French Colonial District and see where European settlement of Illinois had begun. Towns such as Cahokia, Kaskaskia and Prairie du Rocher had been founded by French soldiers and pioneers, passed into British hands at the conclusion of the French and Indian War and became part of the fledgling United States with the signing of the Treaty of Paris in 1783. But the traditional French ways lingered, kept alive by residents who were proud of their region's Gallic heritage.

Later, I began to study the deep southern Illinois region known as Egypt. The old ways lingered there as well, although different in custom and lore than those found in the French communities. Egypt had been settled by families of English and Scots-Irish stock who had migrated from Kentucky, Tennessee, Virginia and the Carolinas. A smattering of other ethnic groups further enriched the cultural potpourri.

I discovered the works of Vance Randolph while a student at the Edwardsville campus of Southern Illinois University and remember being astounded by the sheer volume of lore he collected during his years of fieldwork in the Ozark country of Missouri and Arkansas. Randolph stressed the futility of trying to gather folklore by distributing questionnaires or running "old-timer" columns in newspapers. If one is serious about learning a region's legend and lore, he maintained, one must live among that region's people.

That assertion made sense to me. But I loved living in the River Bend. Besides, many—perhaps most—of the beliefs and customs that so intrigued me had vanished in much of southern Illinois. I needed to connect with older southern Illinoisans, as well as family members with whom they had shared their stories. But how?

I soon learned the importance of networking. My mantra became, "Connect with as many people as you possibly can and let them know what you're seeking." Although some stories and tidbits began to come my way, I wasn't terribly successful until 1979, when I became a regular at Crivello's Book Shop in downtown Alton. Bookshop patrons are always an interesting bunch and come from widely divergent backgrounds. I began to hear some great stuff.

Renamed the Second Reading when it changed hands in 1985, I purchased the bookshop in 1987 and kept it open seven days a week. Now folks knew where to find me at any given time, and the volume of folklore I heard increased greatly. I had begun writing for publication in the early 1980s, just about the time that Gary DeNeal co-founded *Springhouse*, a magazine devoted to everything southern Illinois—particularly its history and folklore. *Illinois Magazine*, a downstate literary institution, had changed hands and was seeking new contributors. I began freelancing for both periodicals, and some of the folklore I had collected found its way into print. The 1990s

saw my articles on southern Illinois folklore appear in publications such as *Country Living* and the *St. Louis Post-Dispatch*.

I have loved Christmas since childhood and delighted in collecting and writing about the folklore of that enchanted season. I noticed last year that the file containing my Christmas articles was bulging. Time to put them into a book, I thought.

There was no question in my mind that such a work should also include the celebration of New Year's and Twelfth Night. A nineteenth-century scholar wrote that "Christmas Day was the morning of the season; New Year's Day the middle of it, or noon; Twelfth Night is the night." I've always agreed with that assessment and have no desire to shortchange readers in relating an account of the Christmas season in southern Illinois.

Some of the traditions you will read about apparently no longer exist, such as the observance of Old Christmas. Others, such as the singing of "La Guiannée" on New Year's Eve, are alive and well, thanks to the efforts of southern Illinoisans who recognize the importance of preserving our region's cultural heritage. And you can be one of them, gentle readers. All that's required is an appreciation of the region's rich legend and lore and a willingness to keep one's eyes and ears open. I believe there are many more treasures just waiting to be rediscovered.

A special thank-you to Sharon Schaefer of Alton's Hayner Public Library, Norma Walker of the St. Clair County Historical Society and Joan Young of the Germantown Public Library for their invaluable research assistance. I am also grateful to Susie Hurford Roth, Gene Haller and Don Floyd for sharing their Christmas memories with me.

Emily Lyons provided photos of the Legend of the Lilies procession at the Immaculate Conception Church in Kaskaskia, while Mary Koester has a plethora of photos of "La Guiannée" and the Kings' Ball. My thanks to the Illinois Historical Preservation Agency and Jarrot Mansion State Historic Site for providing photos of the Jarrot Mansion. All other photos were taken by the author. Dwight Phillips lent his tech support in preparing this book and its photos for electronic submission. Of course, I could accomplish little without the love and support of my wonderful wife, Loretta.

# ❄ Christmas ❄

# Christmas Candles

For most Americans, a candle in the front window during the Christmas season is simply another holiday decoration. For Americans of Irish descent, however, it's part of our history—a beacon of religious liberty that symbolizes a nation's defiance in the face of persecution. I was about six when my great-uncle, Joe Dromgoole, related the story of the candles in the windows. I can still hear the lilt in his voice as he told me how the Irish had started the Yuletide window-candle tradition.

When England ruled Ireland many years ago, he said, its cruel penal code prohibited the Irish from practicing the rites of their Catholic faith. Priests were driven underground and were forced to say the Mass in forests and caves. Some courageous families, however, chose to flout the code and invited priests to say Mass in their homes. Uncle Joe said that every family especially wanted to attend Mass on Christmas Eve, so the wily Irish cooked up a scheme that would enable them to celebrate this holy night right under the noses of their English oppressors.

A family that wanted one of the priests who surreptitiously roamed the countryside to celebrate Mass in its home would place a lighted candle in the window. A passing priest would recognize the signal, and the fortunate family would hear a knock at the door.

Uncle Joe smiled as he told me that the Irish assured the inquisitive English that these window candles were but a revered and harmless

Placing a lighted candle in the window on Christmas Eve is an old Irish custom that many immigrants brought with them to the United States.

tradition. On Christmas Eve, the story went, the Irish recalled the journey of Joseph and Mary in search of shelter in Bethlehem. While there was no room at the inn, a welcoming candle in the window showed that the Irish always had room in their homes as well as their hearts.

"Pure Irish blarney!" Uncle Joe said. Oh, it's true enough that the Irish are the kind of people who would have welcomed the Holy Family with open arms. They would have put them up in the best room of their home rather than in some drafty old stable, according to him.

But those candles had nothing to do with mere sentimentality, Uncle Joe informed me. The practice was born of necessity so that a persecuted people could quietly defy their conquerors and observe their religion without endangering themselves.

Even after the Irish had won the right to attend Mass openly, the practice of placing candles in windows on Christmas Eve persisted and took root in the United States among people of all nationalities and Christian denominations. "When you see candles in windows

at Christmas," he concluded, "remember what the Irish had to go through and how lucky you are to be an American."

Uncle Joe passed away in 1981, but his stories remain. And whenever I see window candles at Christmas, I am reminded of the religious liberty we enjoy.

Uncle Joe's niece—my mother—also lighted a candle at Christmas, but it was placed on a table rather than in a front window. And it couldn't be just any type of candle. It had to be a bayberry. She and her mother had begun this tradition during the Great Depression. "Burning a bayberry candle on Christmas Eve is supposed to bring good luck to a household," my mother explained to me as a child. "During those hard times, Mom and I thought we could use all the good luck we could get!"

Sometimes, though, money was too tight to afford a candle. "Traditions are nice," she said, "but when you have to choose between tradition and food…" And then she would laugh.

When she lighted the candle in our home, Mom would recite an old rhyme about what a bayberry candle on Christmas supposedly did: "A bayberry candle burned to the socket puts food in the pantry and money in the pocket." But if it hadn't "burned to the socket" by the time we were ready to go to bed, out it went. Mother was a cautious woman, and tradition always took a back seat to safety.

During the Vietnam War, our bayberry candle served two functions: it blessed our household and served as a reminder of our troops overseas. As she brought the match to the wick, my mom would whisper, "This is for all the boys who can't be home with their families this Christmas."

She discontinued the custom after I graduated from Southern Illinois University at Edwardsville and started building a life apart from the family. Only once during her twilight years do I remember her purchasing a bayberry candle: on the first Christmas after my father's death in 1993. This time, however, instead of being a tradition of good luck, the candle-lighting was a poignant memorial. "Merry Christmas, Jack," Mother said through her tears, watching the flame dance.

My mom outlived all of the relatives of her generation and most of her friends. She continued to celebrate Christmas with a small

tree and some holiday decorations, but no bayberry candle burned in the house where she lived alone.

Death and divorce had left us a family of two on Christmas 2004, and I celebrated the day with her. I tried to persuade her to light a bayberry candle, but rekindling the old tradition no longer interested her. "It would be too sad with so many of our people gone," she said, yet she was happy we were together. "Thank you for being my son," she said, taking my hand.

My mother died in autumn of 2005 at age eighty-nine. I remarried in 2007, and one of our Christmas traditions is to light a bayberry candle.

# The Ghosts of
# Smallpox Island

I didn't discover Washington Irving's *The Sketch Book of Geoffrey Crayon, Gent.*, with its delightful description of an old English Christmas at the mythical Bracebridge Hall, until I was in college. The fact that Irving had invented the elderly squire who lived on a remote country estate and celebrated a traditional Yuletide was unimportant to me. The Christmas customs depicted in those chapters were absolutely authentic and included such time-honored treasures as the Lord of Misrule, Yule log, wassail and so much more. I was at least vaguely familiar with most of the traditions Irving ascribed to the celebration of Christmas at Bracebridge Hall, but the warmth and color of his words brought the events to life for this reader. Perusing the Christmas section of *The Sketch Book of Geoffrey Crayon, Gent.* became a Yuletide tradition for me.

After the old-style Christmas dinner at Bracebridge Hall, Irving portrayed the squire and parish parson sharing tales of local legends and superstitions. According to the old squire, an effigy of a knight who had participated in the Crusades was thought by the peasants to arise from the tomb it covered and walk about the churchyard on stormy nights. The squire also repeated stories from one of his servants who, in her younger days, had heard that ghosts, goblins and fairies became visible and prowled about on Midsummer Eve.

Today, we generally associate the telling of such tales with Halloween. Years ago, however, ghost stories comprised an important

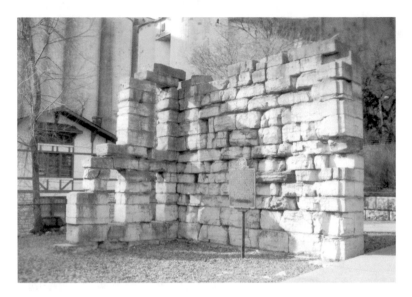

The ruins of the old prison in Alton where Confederate prisoners were incarcerated during the Civil War.

part of the celebration of Christmas. My parents and I, along with my maternal grandmother, who lived with us, traditionally went to Aunt Dot and Uncle Joe's home on Christmas Eve. Presents were exchanged, refreshments were served and Uncle Joe told stories. Since these were family gatherings rather than graduate school classes, I didn't take notes and must now rely on my memory. And I've never forgotten this particular story.

Uncle Joe reminded me that the old penitentiary in Alton had been used to house Confederate prisoners during the Civil War. A terrible smallpox epidemic broke out and swept through the overcrowded prison. Men died like flies, he said.

The early victims of the epidemic were buried in a cemetery located in North Alton, but townspeople feared the contagion would spread to the community's civilian population. Bury these dead somewhere else, they demanded, and get the sick inmates out of Alton! The prison officials built a makeshift hospital on a small island in the Mississippi River, just across from Alton. This island had been known by a number of names, Uncle Joe said, but at that

time it acquired a new name that it would carry for many years—Smallpox Island.

Thousands of men were buried in nameless graves on the island, he told me. I would learn many years later that, while the gist of Uncle Joe's account was true, hundreds—not thousands—of inmates were interred on Smallpox Island. Accuracy, however, isn't vital to the successful telling of a ghost story. Besides, this was entertainment, not some history lesson.

The prison was closed when the Civil War ended, but the horror of Smallpox Island lingered. Townspeople began to hear eerie stories about the place and decided that Smallpox Island was haunted by

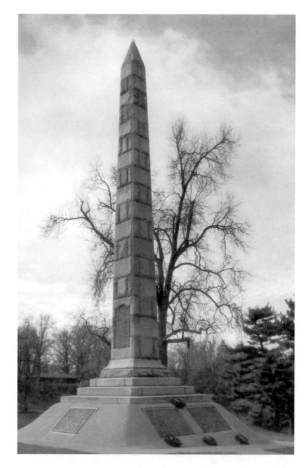

This obelisk honors those prisoners who are buried in the Confederate Cemetery in North Alton.

the ghosts of the Confederates who slept in its soil, so far removed from their families and loved ones in Dixie. Cautious area residents decided the island was a place to avoid.

Some local boys decided to impress everyone with their fearlessness by spending a night on Smallpox Island. Uncle Joe told me that the boys paddled to the island in a canoe, pitched a tent and soon drifted off to sleep. Suddenly, they were awakened by the sounds of approaching footsteps. The embers of their dying campfire shed just enough light for the boys to see some men who were dressed in the filthy remnants of Confederate uniforms, while their eyes were the empty, sightless eyes of the dead.

One of the men who wore a sergeant's stripes on the sleeve of his shirt pointed a spindly finger at the boys, Uncle Joe said. In a voice

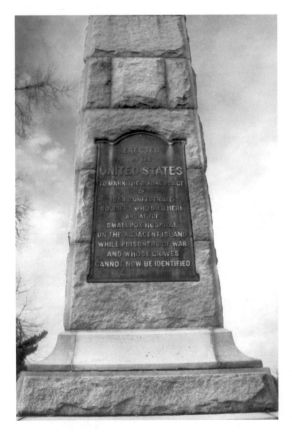

The commemorative plaque on the obelisk in the North Alton Confederate Cemetery.

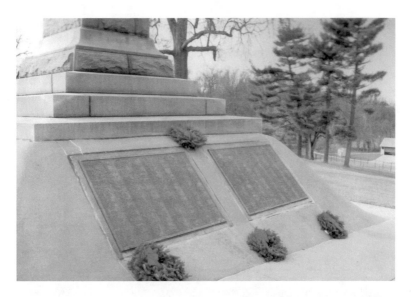

Wreaths are placed each Christmas by the obelisk plaques that list the names of the Confederate prisoners who are buried in the cemetery.

that echoed as though it came from the depths of a vast sepulcher, he icily demanded, "Who dares to intrude upon our resting place?"

This broke the paralysis born of fright. The boys bolted from their tent, jumped into the canoe and paddled furiously back to Alton. Uncle Joe concluded the tale by noting that no one had believed them when they told of their encounter with the Confederate dead. The townspeople simply assumed that the boys had brought a bit of moonshine to the island to warm them against the chill of the river wind.

Like all accomplished storytellers, Uncle Joe took delight in relating his yarns multiple times to the same audience. For the sake of variety, however, he would vary a few details. For instance, while telling this story about troubled Confederate spirits on a different occasion, he substituted "Irish cheer" for moonshine. While my surname is Dunphy, my extreme youth at the time caused me to puzzle over the meaning of Irish cheer. When I asked Uncle Joe, he smiled and replied, "Well, nephew, you might say that it's spirits of a different kind."

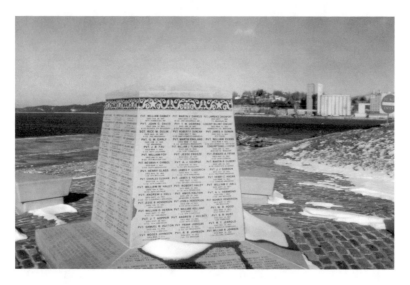

This memorial at the Lincoln-Shields Recreation Area in West Alton, Missouri, honors those Confederate prisoners who are buried on Smallpox Island.

I treasure the memories of those Christmas Eve get-togethers. Unfortunately, I can't compare my reminiscences of them with other family members, since I am the only person still living who attended them. My grandmother died in 1978, Uncle Joe in 1981 and Aunt Dot—the last member of that generation—in 1986. My father died in 1993 and my mother thirteen years later. My mother's cousin and her husband, who also attended our Christmas Eve gatherings, are also deceased. I am now the sole guardian of these memories and thought that I had better commit some of them to paper before they are lost forever. These stories are much too precious to be allowed to vanish with my demise.

# "The Cherry-Tree Carol"

C hristmas carols, played on the radio or performed in church, played an important role in my family's celebration of the holidays. I really can't recall a time when "Silent Night," " Little Town of Bethlehem," "O Come, All Ye Faithful" and the other classic hymns were unknown to me. There was one old hymn that I found particularly intriguing, however. A good part of its fascination for me lay in the fact that I could never hear it sung!

My mother, born in 1916, graduated from high school during the Great Depression. Although she was a good student, going to college was never an option for her. Instead, she went to work.

Uncle Joe, who had only one year of college, tried to help my mother compensate for the higher education our family's poverty denied her. His birthday and Christmas gifts to my mother were usually books. Mother especially loved poetry, and Uncle Joe's 1939 Christmas present always held a special place in her heart. The book she unwrapped that December 25 will forever grace my personal library. It is Louis Untermeyer's *The Book of Living Verse*, published in 1939 by Harcourt, Brace and Company, and I have it opened before me as I write these words.

Uncle Joe's inscription on the flyleaf reads:

> *To Dolly*
> *from*
> *Jodie and Dorothy*
> *December 25, 1939*
> *May poesy and fantasy*
> *brighten many an hour.*
> *For she who reads of the*
> *classic muse, time*
> *is never dull, the*
> *mind never idle.*

"Dolly" was my mother's nickname, while she often called Uncle Joe "Jodie." The inscription, scrawled in Uncle Joe's all-but-indecipherable newspaperman's handwriting, is still legible after all these years.

I began leafing through the work while still in grade school, and although a genuine appreciation of most of the anthology's poems wouldn't come until high school, one selection proved immediately intriguing for a boy who loved Christmas. The section devoted to Old English ballads contained a poem titled "The Cherry-Tree Carol."

"Mom," I asked, "is this a carol like we sing at Christmas?"

"I guess so," she replied, caught a bit off guard by my question. "Let's read it together." And we did.

The poem portrayed Joseph and Mary, who was pregnant with Jesus, walking through a cherry orchard. Mary asked Joseph to pluck a cherry for her. He replied, with a surliness that shocked this Catholic schoolboy, that the man who was the child's father should be the one to pluck the cherry. *Saint Joseph said that to Saint Mary?* I thought to myself. *What a jerk for talking that way to his wife, the mother of Jesus!*

The next part of the carol, however, showed how grumpy old Saint Joseph got his comeuppance. Speaking aloud while still in Mary's womb, Jesus commanded the cherry tree to bend down so that his mother could pluck her fill. Properly admonished by such a

miracle, Joseph apologized to his wife and presumably kept a more civil tongue for the rest of his days.

The carol's lyrics then abruptly forge ahead to record a conversation between Mary and Jesus, who is seated on his mother's knee. Mary asks Jesus what the future holds, and he tells her of his death and resurrection.

I sometimes read "The Cherry-Tree Carol" over the years but, having no idea of its melody, never attempted to sing it. No one from my childhood and adolescence, even Uncle Joe, was even vaguely familiar with it. The plot of "The Cherry-Tree Carol" intrigued me to no end. There was nothing in the four Gospels, or anywhere in the Bible, regarding Jesus speaking from the womb to acquire cherries for his mother.

Years later I would learn that "The Cherry-Tree Carol" is yet another folk song, like "Bonny Barbara Allan" and "Greensleeves," that journeyed with English settlers to the New World. I also discovered that the text contained in *The Book of Living Verse* is merely one of several versions that were sung at Christmas in the Britain and America of long ago. Each variation of the carol, however, has Mary wanting some cherries, Joseph refusing to pick them for her and the cherry tree miraculously bending down so that Mary can obtain the fruit.

While this incident is missing from the canonical scriptures, scholars note that a similar incident is recorded in the Gospel of Pseudo-Matthew, a text excluded from the New Testament. During the flight into Egypt, according to Pseudo-Matthew, the exhausted Mary asked Joseph to let her rest beneath the shade of a palm tree. Looking up, Mary saw its fruit and told Joseph how much she would like some. The baby Jesus then commanded the palm to bend down so Mary and Joseph could gather its fruit. Jesus also ordered the palm's roots to give water to his thirsty parents.

Perhaps the anonymous author of "The Cherry-Tree Carol" was familiar with the Gospel of Pseudo-Matthew. What *is* certain is that the song was a favorite Yuletide hymn in much of the rural America of years past. I last heard "The Cherry-Tree Carol" when St. Louis radio station KDHX played a beautiful rendition that had been recorded by Emmylou Harris. Although variants of the carol still

exist in Kentucky, it evidently hasn't been performed in southern Illinois for many years. Soon, however, that will change.

Nancy Lippincott, a New Jersey native who has lived in Godfrey for decades, is a singer, songwriter and musician who has mastered five instruments: guitar, mandolin, autoharp, banjo and hammered dulcimer. Her musical repertoire includes Celtic, folk, bluegrass and early country. She has performed for years throughout southern Illinois and the nearby St. Louis area. A longtime and treasured friend, Nancy has informed me that she intends to learn "The Cherry-Tree Carol" and include it in her performances during the holiday season. This beloved, time-honored Christmas song will return to southern Illinois.

# The Christmas Tree in Southern Illinois

As a child, I had a friend whose family was German descended and proud Lutherans. Christmas was my friend's time to shine about his ethnic heritage, as well as his religion.

"Do you know why we have Christmas trees?" he asked during more than one holiday season. "It's because of Martin Luther," my friend replied as he proudly answered his own rhetorical question. His family had passed down for generations a popular legend of the Christmas tree's origin, and he was never reluctant to share it with others not fortunate enough to have been born into the German Lutheran tradition.

It seems that Martin Luther took a walk through a snowy forest just before Christmas. He was struck by the beauty of the stars as they gleamed through the branches of the evergreens. The founder of the faith that to this day bears his name wished that his wife and children could also enjoy this majestic scene. Suddenly, he knew how he could share it with them. He cut down a small evergreen and took it home, where he bedecked it with lighted candles to replace the stars.

Scholars have long noted that Luther's voluminous writings contain no mention of this incident, but the story—which is almost certainly apocryphal—acquired a life of its own in the regions of Germany where Lutheranism had triumphed. Having a Christmas tree became so closely identified with following Luther's path that

A giant Christmas tree at Lincoln-Douglas Square in Alton, where the final debate between Abraham Lincoln and Stephen Douglas was held in 1858. Statues of the two statesmen are in the foreground.

German Catholics initially wanted nothing to do with this symbol of Protestantism. Their resistance endured until the nineteenth century, when Christmas trees finally began finding their way into Catholic homes.

Since I had been raised a Catholic, I gave little credence to my friend's account. My teachers in parochial school informed us that our dearly beloved Christmas trees owed their existence to a good Catholic saint—St. Boniface, to be precise. An eighth-century English monk, Boniface founded the first Christian churches in France and Germany, where he battled a plethora of entrenched pagan customs.

According to this story, Boniface encountered some Germanic tribesmen on Christmas Eve who had gathered around a huge oak tree and were about to sacrifice the child of their chief to Thor. As one might expect, Boniface took a decidedly dim view of this enterprise and thwarted it with a display of the kind of supernatural power that saints are always able to manifest in such situations: he toppled the mighty oak with a single blow of his fist. A small fir

tree then sprang up from the ground. This tree, Boniface explained, symbolized Christ, who was born on this night to supplant Thor and all the pagan gods of the world.

As an adult, when I began the study of Christmas folklore in earnest, I discovered yet another tale set in Germany that supposedly explains the origin of the Christmas tree. A hermit who dwelled deep in the forest was awakened on a snowy Christmas Eve by a gentle tapping at his cottage door. He was astounded to find a small child, dressed in tattered rags, who begged shelter for the night. The small stranger's plight touched the hermit's heart, and he bade the child to enter.

The hermit shared his meager food with the child and even slept on the floor so that the little one could sleep in the cottage's crude bed. On Christmas morning, he again gave the child food to eat, as well a blanket to take with him on his journey. As he stepped out the cottage door, the child turned to face the hermit and blessed him for his kindness. Suddenly, the little one's countenance began to glow with a holy light, for he was none other than the Christ Child, whose mother and father had been denied a room at the Bethlehem inn on the night of his birth. Now, he journeyed the world in disguise to bless those who offered shelter to poor strangers on the anniversary of his birth.

The Christ Child then vanished before the astonished hermit's eyes. He was beginning to wonder whether he had imagined this whole episode when a small fir tree miraculously sprang up through the snow beside his cottage door. The morning sun made the snow and ice on its branches glisten like tiny fires. The hermit took the tree into his cottage, and when the snow and ice melted, he placed lighted candles on its branches so they would again glisten. This little fir, brought into existence by the Christ Child himself, became the first Christmas tree.

It's a beautiful story and will always hold a special place in my heart. Of course, the reality of the Christmas tree's genesis is considerably less prosaic, although no less interesting. When I began my study of folklore in the 1970s, it was the general consensus that the Christmas tree tradition began during the Middle Ages. Christmas in Germany during that era was celebrated by the performance of

public plays that illustrated the creation by God of Adam and Eve, their fall through disobedience and the expulsion of the first man and woman from the Garden of Eden. Variously called Paradise plays, Miracle plays and Mystery plays, they invariably culminated in the promise of redemption through the birth, crucifixion and resurrection of Jesus. These plays were performed with only one stage prop—the *Paradeisbaum*, German for the Paradise tree. A fir tree with apples hanging from its branches, the Paradise tree represented the Tree of the Knowledge of Good and Evil that had grown in the Garden of Eden; hence the name, Paradise tree. While the Bible doesn't mention precisely what kind of fruit was borne by the Tree of the Knowledge of Good and Evil, the apples dangling from the Paradise tree gave rise to the belief that Eve must have plucked an apple that tasted so delicious that she persuaded Adam to sample this "forbidden fruit."

Although staged to teach Christian truths to a public that was largely illiterate, the Paradise plays gradually became irreverent and were banned by church authorities. The Paradise tree, however, had become so beloved by the German people that families began setting them up in their homes during the Christmas season. Apples were still used to adorn these trees, but families supplanted the fruit with small white wafers that symbolized the Holy Eucharist. As the Paradise tree slowly evolved into the more secular Christmas tree, the wafers were replaced by small pastries, cookies and cakes that had been baked to resemble Nativity figures, such as Mary and the Magi.

While many German families adopted the Christmas tree tradition, other homes displayed the Christmas pyramid, which consisted of a set of shelves stacked one above the other to resemble that geometric shape. The shelves were filled with fruit and gifts, while candles placed along the shelf edges glowed like stars. The Christmas pyramid seriously rivaled the Christmas tree in Germany during the Middle Ages. By the sixteenth century, however, the Christmas tree had emerged as the victor in this holiday popularity contest, although the pyramid lingered in a few rural areas even into the early twentieth century. A fragrant evergreen, vibrant and alive even in the dead of winter, was simply more appealing

than wooden shelves, however gaily decorated. Still, the Christmas pyramid profoundly influenced the modern Christmas tree: the candles that once flickered on its shelves were transferred to the branches of the evergreen.

Historians such as Stephen Nissenbaum, who wrote the landmark 1997 work *The Battle for Christmas*, now believe that the German Christmas tree is a much more recent innovation. The custom began in the early sixteenth century in Strasbourg, the capital of Alsace. Johann Wolfgang von Goethe visited Strasbourg and learned of the city's Christmas tree tradition. Goethe was so impressed that he shared it with his literary colleagues. He even included a scene that featured a Christmas tree in his 1774 novel *The Sorrows of Young Werther*, the work that secured his reputation.

The Strasbourg tradition spread throughout Germany. By the 1830s, the Christmas tree was a national custom and the most beloved holiday tradition in Germany. Clement Miles, writing in 1912, observed that no German was too poor or lonely to lack a Christmas tree. He stated that, in the England of his day, a Christmas tree was still a luxury for the well-to-do.

According to Miles, the Christmas pyramids of medieval Germany were also set up in England prior to 1840. Queen Victoria and Prince Albert put up a Christmas tree that year, and the upper classes, always eager to emulate the ways of the royal family, soon adopted the custom.

Christmas trees were introduced into the United States by German immigrants, as well as through the efforts of Americans who had learned of the custom. John Lewis Krimmel, a German painter who had immigrated to Pennsylvania, drew a sketch of a German family in that state who were celebrating Christmas. The eleven-member family is gathered around a small Christmas tree. Krimmel's sketch, drawn in either 1812 or 1819, is historically important as the first sketch of an American Christmas tree, although it would not appear in print until the late twentieth century.

British author Harriet Martineau wrote an account of a Christmas tree that had been set up in 1835 by German immigrant and Harvard professor Charles Follen. The first visual depiction of a Christmas tree in our nation to be printed appeared in 1836

as the frontispiece of *The Stranger's Gift*, which was written by Herman Bockum, a German immigrant who taught his native language at Harvard.

American-born Catharine Sedgwick's 1835 short story, "New Year's Day," portrayed a New York family of old Yankee stock that set up a Christmas tree adorned with presents for the children. The tree, which was put up on New Year's Day rather than Christmas, was the idea of the family's servant, who was a German immigrant.

Germans who settled in southern Illinois brought the custom with them. While the year that the first Christmas tree made its appearance in our region can't be conclusively established, the earliest account I've discovered dates from 1833. Gustav Koerner, in the first volume of his *Memoirs*, included a description of the first American Christmas celebrated by the Engelmann and Hilgard families on their farm near Belleville. This narrative includes a delightful sketch of Belleville on Christmas Eve of that year:

> *On my return from St. Louis on the evening of the twenty-fourth, I passed through Belleville after dark. In spite of the mud in the streets they were lively. The Americans celebrate Christmas in their own way. Young and old fired muskets, pistols and Chinese fire-crackers, which, with a very liberal consumption of egg-nog and tom-and-jerry, was the usual, and in fact, the only mode of hailing the arrival of the Christ-Child.*

One detects that Koerner's sensitivities were offended by the raucousness of an American Christmas celebration. His description of the Engelmann-Hilgard families' observance of Christmas Day conveys the warmth and simplicity of a traditional German Christmas:

> *On Christmas day, 1833, we had a Christmas tree, of course. In our immediate neighborhood we had no evergreen trees or bushes. But Mr. Engelmann had taken the top of a young sassafras, which still had some leaves on it, had fixed it into a kind of pedestal, and the girls had dressed the tree with ribbons and bits of colored paper and the like, had put wax candles on the*

*branches, and had hung it with little apples and nuts and all sorts*
*of confectionary, in the making of which Aunt Caroline was most*
*proficient. Perhaps this was the first Christmas tree that was ever*
*lighted on the banks of the Mississippi.*

Until an earlier account surfaces, we must assume that this was not
only the first Christmas tree lighted on the banks of the Mississippi
but also the first lighted in southern Illinois. The custom of putting
up a tree gradually spread to the region's non-Germans to enhance
their enjoyment of Christmas. In a few decades, those "Americans"
whose "only mode of hailing the arrival of the Christ Child" was
drinking and discharging weapons shared the Engelmann-Hilgards'
affection for the Christmas tree.

Poverty sometimes prevented a family from setting up a tree—
Uncle Joe grew up poor in Alton's Hunterstown district, where such
seasonal luxuries were rare indeed—but Christmas trees became
popular with all ethnic groups. Rural southern Illinoisans who
owned land that included evergreens selected a tree of the right
height and went to work on it with an axe. City dwellers, like my
family, chose their trees from those offered for sale on lots. Folks in
the southern Illinois of my childhood generally frowned on artificial
trees and associated them with the kind of Yuletide decorations
found in bars and other places that were inherently incompatible
with the true spirit of Christmas.

Illustrations of early Christmas trees invariably show them
bedecked with lighted candles. While the traditional German
Christmas tree invariably featured candles, this custom wasn't
always observed by practical-minded southern Illinoisans who
generally recognized a fire hazard when they saw one. My mother's
family set up a Christmas tree that might once have featured
candles, although mom's memory was a bit shaky on this detail.
She was quite sure about one thing, though: as a child, she always
heard about at least one home in the Alton area catching fire
because a family eschewed those new-fangled electric Christmas
tree lights in favor of old-fashioned candles. My mother's family
had little enough as it was and possessed no desire to risk losing its
home and possessions.

A southern Illinois woman told me about visiting her grandparents at Christmas, who lived on a gravel road near Old Furnace. It was an old-fashioned dwelling that featured an outhouse for use during good weather and a chamber pot for the winter months. Meals were prepared on a wood-burning stove in the kitchen. The grandmother made fried chicken "from scratch," which her granddaughter defined as "the chicken was scratching around in the yard the morning she cooked it." A coal stove heated the living room. While it undoubtedly kept the room warm during even the frostiest days and nights, this stove precluded the couple from having a Christmas tree. They were afraid the tree might catch fire.

As a child, mom lived next door to a German family that took delight in adorning its Christmas tree with a rich array of glass ornaments, many of them handcrafted in Germany, that any contemporary antiques dealer would drool over. When mom mentioned that this family's prized ornament was shaped like a pickle, I thought her memory must be playing tricks on her. A little research as an adult convinced me that mom was as sharp as usual.

The pickle ornament is more than merely another item to hang on the tree. It embodies a beloved German Yuletide tradition. On Christmas Eve, after the children have gone to bed, parents hang this glass pickle on the Christmas tree. The child who finds it on Christmas morning receives a special present.

Our family had a reasonably good collection of glass ornaments and other curios for trimming our tree—but no pickle. One Christmas, while hearing mom fondly recalling that German family's pickle ornament and wishing we had one, my father decided to have a little fun.

"Do you really want a pickle ornament for the tree?" he asked.

"Oh yes, Jack!" mom replied.

"Okay, I'll get you one," he replied. He entered our kitchen and emerged with a dill pickle slice that he had taken from the refrigerator. "Get me one of those hooks and I'll hang it up for you."

Mom was not amused.

While browsing through a shop in 2009 that specialized in traditional German Christmas memorabilia, I purchased a pickle

ornament that now graces our tree. While there are no small children to seek it among the branches on Christmas morning, my wife and I treasure it as part of an old-fashioned Yuletide celebration. Mom would be pleased to know that the Dunphy household at last has a pickle ornament—and not the kind placed on a hamburger.

Mom's childhood Christmas tree was trimmed on a budget, like the vast majority of trees in the southern Illinois of long ago. The most popular way—not to mention the least expensive—to trim a Christmas tree was to decorate it with popcorn that was strung together with needle and thread. Strands of ribbon gave the tree color, along with glass ornaments that were carefully wrapped in newspaper and stored away in the attic or basement. Some families fixed small apples to the tree's studier branches.

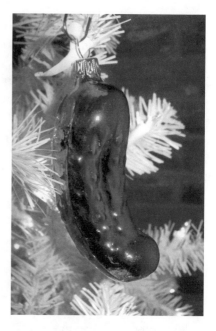

The pickle ornament is an old German tradition. The child who finds it on Christmas morning receives a special gift.

A bird's nest in the Christmas tree was thought to bestow a year of good luck, so families in rural southern Illinois would search for an evergreen that had one in its branches. Other families, both rural and urban, simply removed a bird's nest from any tree and placed it in their Christmas tree, a practice that any find-a-bird's-nest-in-an-evergreen traditionalist surely regarded as breaking the rules. My family, of course, never had a bird's nest in our tree. Mom was familiar with the custom but pointedly observed that baby birds are not toilet-trained and use their nest as a high-altitude outhouse. Such a nasty item would never be found in *her* Christmas tree.

Thanks to the efforts of enterprising entrepreneurs, anyone can have a perfectly clean bird's nest in their tree. I purchased a bird's nest ornament in the same shop where I bought the pickle, and both now grace the Christmas tree in our home. Ensuring a year of good luck has never been easier—not to mention more sanitary.

Another interesting ornament that hangs from the Dunphy family tree celebrates St. Lucia, whose traditional feast day of December 13 places her squarely in the Christmas season. The ornament features the head of a young woman who is wearing a wreath of candles, which is the traditional depiction of St. Lucia. At the first cock's crow on December 13 in the Sweden of long ago, the prettiest girl donned a white robe with a red sash. She then carefully placed on her head a wire crown covered with whortleberry twigs that had nine lighted candles fastened to it. The girl then awakened the sleeping family members.

Every tree that I can recall seeing or hearing described during my childhood was considered incomplete until a star was fixed to its top. Whether Protestant or Catholic, southern Illinois families recognized a large star ornament as symbolizing the star followed by the wise men in their quest to find the Christ Child, as recorded in the second chapter of the gospel according to Matthew. Like most Americans, we used the terms "wise men" and "three kings" interchangeably when referring to these esteemed pilgrims. Someone would occasionally point out that Matthew's account makes no mention of their number or royal standing and identifies them simply as wise men. We would consult a Bible to verify this correction, thank the party for this insight and then return to calling the gentlemen in question "the three kings." We southern Illinoisans are set in our ways.

As a Catholic family, though, we had ample reason for asserting that the star atop our tree honored three kings. A tradition exists in the Catholic Church that these visitors to the young Jesus were three in number and kings indeed, who were named Caspar, Melchior and Balthazar. When Protestant friends admonished us that these names were absent from Matthew's gospel, we replied that Catholic faith relied on tradition as well as scripture. They remained unimpressed.

Still, all of us agreed that a true Christian home always had a star atop its Christmas tree. This star ornament was a matter of such importance to some families that it even determined the location of their trees. They insisted that, since it was a star in the east that led the wise men to Jesus, a Christmas tree should be placed against an eastern wall. Other families asserted that Matthew's quotation of the wise men's statement to Herod, "we have seen his star in the east," meant that these pilgrims lived in the east, where they had seen the mysterious star shining

The author's Christmas ornament depicts St. Lucia wearing a wreath of candles.

in what would have been for them the *western* sky. Therefore, a Christmas tree really belonged against a western house wall. Fortunately, the vast majority of southern Illinois families were practical-minded and had no inclination to split scriptural hairs. A star-topped Christmas tree belongs beside the most prominent window facing the street or road. My family's tree was always visible from the street but was not meant to awe all who passed by with any elaborate or expensive ornamentation. Our tree was not a status symbol meant to impress other people. It was there to add an additional measure of joy to the holiday season, courtesy of the Dunphy family. It was our piece of a puzzle that, when fully assembled, proclaimed that Christmas was the most joyous time of the year.

# The Message in a Christmas Tree

B uying a Christmas tree was always a beloved part of my childhood. My parents and I would drive to a local business that had transformed its parking lot into a temporary pine forest and select the one that was right for our home. We didn't want a Charlie Brown tree, mind you, but nothing too gargantuan, either. I can recall us sometimes purchasing two trees: a large one to hold all our traditional ornaments and strings of lights as well as a small tree. The latter was mine to decorate with ornaments that I had made myself. I prided myself as the Michelangelo of Play-Doh and used the stuff to create miniature Christmas trees, stockings, wreaths and other Yuletide objects, some of which defied identification.

We sometimes bought our trees at Wegener's Grocery Store, a family-owned business not far from our Alton home. During the Christmas season of 1958, an employee of the store found something in one of its Christmas trees—and I'm not talking about a bird's nest or pine cone. Beach dwellers sometimes toss a bottle containing a note into the ocean in the hope that it will eventually reach someone who resides far away. A Canadian boy in 1958 decided to dispatch a letter using a Christmas tree rather than a bottle.

The letter, dated November 17, 1958, began, "Destination Unknown, from Canada" and was written by Bernard Bidard, a ten-year-old Canadian boy. The boy lived in French-speaking Quebec and wrote the letter in that language. The Wegener

employee who found Bernard's letter took the missive to a friend to have it translated.

Bernard stated that the tree had been grown on his father's farm in the little village of St. Fortunate in Wolfe County. He wrote that he didn't know where this tree would spend "the feast days" but hoped it would bring happiness to other children like himself. The lad noted that the villagers of St. Fortunate "are not rich, but one must know how to deprive oneself of luxuries in order to have the necessities." Bernard closed the letter by saying that he and his brothers, ages seven and eight, hoped to have a good Christmas, and he wished that the readers of his letter have a Merry Christmas and a Happy New Year.

The discovery of Bernard's letter in a Christmas tree was the talk of Alton and the entire River Bend area that 1958 Yuletide. The fact that this incident occurred at Wegener's Grocery Store only added to its charm. Wegener's was a respected and well-known area business where many families—including mine—bought their groceries for years. This store again made the news the very next year, but this time the event was anything but heartwarming. Wegener's was robbed at gunpoint by two men. My father's mother, who lived next door to Wegener's, was shopping in the store when the crime was committed. One of the malefactors was a career petty criminal who had been born in 1928 at 1021 West Ninth Street in Alton. His name was James Earl Ray, and in 1968, he assassinated Dr. Martin Luther King Jr.

Wegener's Grocery Store is long gone, although another family-owned grocery now occupies the building. When I shop there during the holiday season, I always think of that long-ago Canadian boy whose Christmas letter touched the hearts of an entire community.

# A Literary Christmas
# in Herrin

Hal W. Trovillion (1879–1966) left Indiana University in 1904 to become the publisher of two newspapers in Herrin, Illinois. Four years later, he founded the Trovillion Private Press at the Sign of the Silver Horse to publish small books that were limited to press runs of a few hundred copies. The books were brief, usually fewer than fifty pages, printed on high-quality European paper and produced by his newspaper printers. His wife, Violet Trovillion (1890–1979), served as proofreader. Each copy was personally numbered and signed by the Trovillions.

Between 1908 and 1960, the Trovillion Private Press at the Sign of the Silver Horse published about seventy small books, all of which are now regarded as collectible. Their subject matter included local history (*The Bloody Vendetta; A History of Williamson County, Illinois* by Milo Erwin; 1914, 500 copies), works by famous authors (*The Selfish Giant* by Oscar Wilde; 1932, 128 copies), personal essays by the Trovillions (*No More Dogs at Thatchcot*; 1944, 321 copies) and obscure old works by English authors (*Countrie Housewife's Garden* by William Lawson, written in 1617; 1948, 997 copies). The Trovillions called their home Thatchcot, since its roof was designed to appear as though it were thatched.

Hal and Violet Trovillion loved Christmas, and several of these small books deal with the holiday season. The best appeared in the autumn of 1947. *Christmas at Thatchcot* was printed on Van Gelder

paper in Baskerville type and limited to 711 copies. The importance of the Christmas season to the Trovillions is evident from the first page: "Christmas to us has ever been a season filled with joyous excitement. It is the one day in the long calendar of the year in which we all seem to soften up and view the world as a friendly place to dwell. Most of the people about us appear to be friends and we deal one with another as if brothers in the flesh."

The Trovillions noted that it had been their custom for years to send to their friends at Christmas a small book, folder or card that had been printed by their private press. The remainder of *Christmas at Thatchcot* contains selections from those previous holiday publications. The sheer variety of these selections reflects the diverse literary tastes of the Trovillions. One would have been surprised had they not chosen to reprint little Virginia O'Hanlon's letter to the *New York Sun* concerning the existence of Santa Claus. Two passages from *A Christmas Carol* by Charles Dickens graced another Christmas greeting, the first featuring Scrooge's celebrated rant:

> *What's Christmas time to you but a time for paying bills without money; a time for finding oneself a year older and not an hour richer; a time for balancing your books, and having every item in 'em through a round dozen of months presented dead against you? If I could work my will, every idiot who goes about with "Merry Christmas" on his lips should be boiled with his own pudding and buried with a stake of holly through his heart. He should!*

The second passage reflected Scrooge's change of heart after that visit from Marley's ghost and the three spirits:

> *"A Merry Christmas, Bob!" said Scrooge, with an earnestness that could not be mistaken, as he clasped him on the back. "A merrier Christmas, Bob, my good fellow, than I have given you for many a year! I'll raise your salary, and endeavor to assist your struggling family, and we'll discuss your affairs this very afternoon, over a Christmas bowl of smoking bishop, Bob! Make up the fires, and buy another coal-scuttle before you dot another i, Bob Cratchit!"*

Like many Americans, the Trovillions found it difficult to reconcile the spirit of Christmas with the horrors of war. The old refrain of "Peace on earth, good will toward men" sounded empty and meaningless in December 1941, with the United States embroiled in World War II. The Trovillions turned to the optimistic poetry of Walt Whitman for that year's Christmas greeting and sent these lines to their friends:

> *Keep heart, O comrade;*
>  *God may be delayed*
> *By evil, but he suffers no defeat.*
> *God is not foiled;*
>  *The drift of the World Will*
> *Is stronger than all wrong.*

With the world still at war in 1943, the Trovillions found solace in a poem by Princess Zeb-un-Nissa, daughter of the last major mughal emperor to rule the Indian subcontinent. These were the lines the Trovillions shared with their friends:

> *TOMORROW*
> *At every dawn I say—*
> *If not today,*
> *My joy will come tomorrow.*
> *And hoping for delight,*
> *Dawn becomes night:*
> *Till, thus deceived, I find*
> *Unto my sorrow*
> *At last*
> *That, hoping for tomorrow*
> *My life has passed.*

*Christmas at Thatchcot* concludes with two holiday selections for 1947, its year of publication. The Trovillions reprinted Nicholas Breton's "Christmas Day" from his *Fantasticks*, originally published in 1626. It is a charming description of an old English Christmas celebration as well as a paean to the season:

# Christmas

*Christmas Day*
*It is now Christmas, and not a cup of drink must pass without*
*a carol. The beasts, fowl and fish come to a general execution,*
*and the corn is ground to dust for the bakehouse and the pastry…*
*Now good cheer and "Welcome, and God be with you," and "I*
*thank you," and against the New Year provide for the presents.*
*The Lord of Misrule is no mean man for his time, and the guests*
*of the high table must lack no wine. The lusty bloods must look*
*about them like men, and piping and dancing puts away much*
*melancholy. Stolen venison is sweet, and a fat coney is worth*
*money…A good fire heats all the house, and a full alms-basket*
*makes the beggars prayers. The Maskers and the Mummers make*
*their merry sport; but if they lose their money their drum goes*
*dead. Swearers and swaggerers are sent away to the alehouse,*
*and unruly wenches go in danger of judgment. Musicians now*
*make their instruments speak out, and a good song is worth*
*the hearing. In sum, it is a holy time, a duty in Christians for*
*their remembrances of Christ, and custom among friends for the*
*maintenance of good-fellowship. In brief, I thus conclude it: I*
*hold it a memory of Heaven's love and the World's peace, the*
*mirth of the honest and the meetings of the Friendly. Farewell.*

The Trovillions' second selection for Christmas of 1947 was
Alexander Smith's 1862 essay "Dreamthorp," a beautifully written
if somewhat melancholy reflection on a solitary Christmas spent
by its author. "Sitting here, I incontinently find myself holding a
levee of departed Christmas nights. Silently, and without special
call, into my study of imagination come these apparitions, clad in
snowy mantles, brooched and gemmed with frosts. Their numbers I
do not care to count, for I know they are the numbers of my years."

Smith attended church and found the service particularly
touching. "The clerk," he observed, "read the beautiful prayers
of our Church, which seem more beautiful at Christmas than any
other period." Smith left the church with the other worshipers and
returned home. Unlike so many other residents of Dreamthorp,
however, he must spend Christmas alone. Yet he was not lonely.
"I have no one with me at table, and my own thoughts must be

my Christmas guests. Sitting here, it is pleasant to think how much kindly feeling exists this present night in England. By imagination I can taste of every table, pledge every toast, silently join in every roar of merriment. I become a sort of universal guest."

He applauded the compassion that permeates the Christmas season and noted, "There is more charity at this time than at any other." Actions that one ordinarily found annoying now brought delight. "You get up at midnight," he remarked, "and toss your spare coppers to the half-benumbed musicians whiffling beneath your windows, although at any other time you would consider their performance a nuisance, and call angrily for the police."

After noting that "for at least one night on each year over all Christendom there is brotherhood," Smith concluded his essay with the hope that this brotherhood someday would be evident every day of the year. And so ends *Christmas at Thatchcot*. The Trovillions could hardly have chosen a denouement for their little book that better embodies the yearnings of their fellow southern Illinoisans and everyone who celebrates Christmas.

# Santa's Christmas Eve Ride Reinvented

Southern Illinois children believe that Santa Claus drives a sleigh pulled by a team of reindeer that magically possess the gift of flight. As a child, however, I reinvented the Jolly Old Elf's journey across the sky by giving it a regional twist. In order to appreciate the ingenuity and sheer originality demonstrated by that long-ago schoolboy, however, one must be acquainted with the premier legend of southwestern Illinois.

Visitors to Alton are always fascinated by a painting that adorns the great limestone bluffs just beyond the city limits on Illinois Route 100. The image depicts a huge, winged creature with deer antlers and talons that look as though they could pierce the top of a boxcar. This monster, known as the Piasa (pronounced *pie´-a-saw*) Bird, and its curious saga are four centuries old.

While exploring that stretch of the Mississippi River near the present-day site of Alton in 1673, the explorers Father Jacques Marquette and Louis Jolliet saw two Native American pictographs on the bluffs. These "monsters," as Marquette referred to them in his journal, were as large as calves but had deer horns on their heads. He also noted that the creatures had red eyes, bearded faces and bodies covered with scales. Both monsters sported long tails that wound completely around their bodies.

The pictographs were so well executed that Marquette found it difficult to believe that they had been painted by Native Americans.

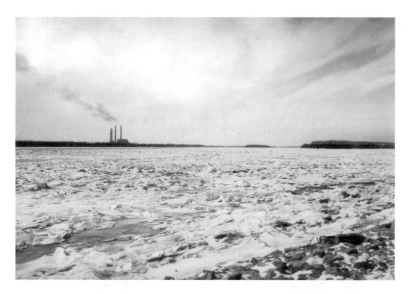

The Mississippi River, which composes the western border of southern Illinois and flows past the author's hometown, often freezes during the holiday season.

Even the most talented French painters, he confided in his journal, would have found it difficult to produce such works. The priest concluded his account by sketching the creatures, but his drawings have not survived for us to examine. Neither Marquette's nor Jolliet's journals of the expedition made any mention of Indian legends that explained the pictographs' significance. It is also important to keep in mind that Marquette's descriptions of the creatures contained no mention of wings.

Although several travelers passing through the area during the ensuing years reported seeing the mysterious paintings, some scholars have concluded that the figures were obliterated by the elements soon after their discovery by Jolliet and Marquette and could not have been visible after 1700. But public interest in the pictographs never waned.

John Russell, a teacher and writer who had moved to Illinois, heard of the paintings while teaching at Shurtleff College in Upper Alton. His article, "The Piasa: An Indian Tradition of Illinois," appeared in the August 1836 issue of *The Family Magazine; or The*

*Monthly Abstract of General Knowledge.* Signed only with the initials "J.R.," the article was reprinted in several Illinois newspapers.

Russell claimed in the article that, long before the arrival of pioneer settlers, Indians of this region had been terrorized by a fierce, winged demon that they called the Piasa, which Russell claimed was an Illini word meaning "the bird that devours men." Modern scholars, however, have long noted that the Illini language contained no such word.

Russell stated that the Piasa was so huge that it could carry off a deer in its talons. Once having tasted human flesh, however, it would prey on nothing else. Entire villages were depopulated, and the Illini realized that the Piasa must be destroyed.

Ouatoga, an Illini chief who lived near present-day Godfrey, prayed to the Great Spirit for guidance. The Indian deity appeared to him in a dream and directed Ouatoga to select twenty of his best warriors, arm them with bows and arrows and conceal them in a designated place. Ouatoga, acting as live bait, stood on a bluff to attract the Piasa. As the bird swooped down to attack Ouatoga,

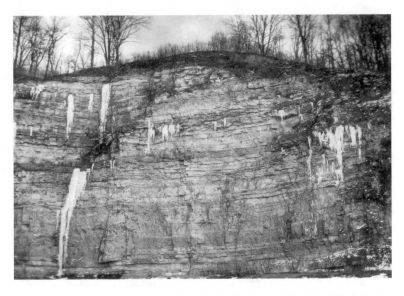

Frozen waterfalls on the limestone bluffs bordering the stretch of the Mississippi that runs past Alton, Illinois, the birthplace of the author.

the braves merged from cover and shot their arrows into the beast. Screaming in pain, the Piasa flew to the other side of the Mississippi and died. The Indians then painted the Piasa's image on the bluffs to commemorate their victory over this predator.

Russell astutely saved the most incredible portion of this tale for the conclusion. He claimed that a guide took him to a local cave in March 1836 that had long been associated with the Piasa tradition. There they discovered the "sculls" [*sic*] and bones of the Piasa's victims. He and his guide dug to a level of three or four feet in every corner of the cave, Russell informed his readers, and found nothing but bones—perhaps the remains of thousands.

Years later, Russell published another version of the Piasa legend that contained significantly different details, but this was the account that caught the public's attention. Depictions of the winged monster became the most enduring and widely recognized symbol of southwestern Illinois. Area residents couldn't have cared less when twentieth-century scholars conclusively demonstrated that the legend was not authentic Native Americana. The saga of a flying

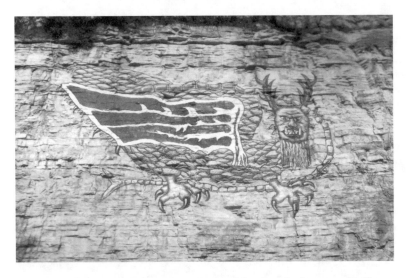

The most recent depiction of the Piasa Bird is painted on the limestone bluffs on Illinois Route 100 at Alton.

monster that preyed on Indians had acquired a life of its own that was impervious to mere academic refutation.

Local artists painted the Piasa on the bluffs, always replacing it when the elements inevitably faded its image. Entrepreneurs took the name for their businesses. When I was a child, there was a Piasa Savings and Loan in Alton, and today I access the Internet through a local server called Piasanet. One of the principal streets in downtown Alton is Piasa, while a small town on Illinois Route 16 bears the name Piasa. The Piasa Creek meanders through Jersey County before emptying into the Mississippi, while the Little Piasa Creek once bisected downtown Alton itself. The Little Piasa was covered over years ago and now flows into the Mississippi beneath Piasa Street.

As an Alton native, I grew up in a culture saturated with the Piasa Bird. Despite its omnipresence, however, the creature had never been associated with the Christmas season. At the tender age of six, I changed that.

Some relative had given me a coloring book of holiday images, and I immediately concerned myself with shading in the figures of candy canes, wrapped presents and other Christmas icons. A drawing of a Santa Claus in his flying reindeer–drawn sleigh gave me an idea that seemed at the time nothing less than astonishing in its ingenuity. I quickly obtained a blank sheet of paper and set to work with my crayons. A short time later, I presented a drawing to my mother.

"Where did you get this idea?" she asked incredulously.

"I thought of it myself," I replied, with that special pride only children possess.

"But *what* gave you the idea?" Mom asked.

"Well, reindeer are okay, but think how fast the Piasa Bird could pull his sleigh!" I said. My crayon drawing indeed depicted Santa in a gift-laden sleigh that was being pulled by the Piasa Bird rather than reindeer. The creature, with the huge teeth and claws I had given it, was its usual menacing self, but Santa was grinning from ear to ear, seemingly oblivious to the possibility that the Piasa might decide Old St. Nick would be a tasty snack.

Mom shared my masterpiece with all the relatives, as well as everyone she had known since the first grade. They agreed, or

pretended to agree, that little John Dunphy possessed a creativity that rivaled Walt Disney's and surely must be destined for great things. Whether they were correct in that analysis I leave to my readers.

Although my mother devoutly saved many of my childhood artwork and writings, the Santa–Piasa Bird drawing must be presumed lost to posterity. I hadn't thought about it in years until one day in the late 1980s, when a customer entered my bookshop bearing a commercially produced drawing that bore the caption: "Christmas on the Bluffs." Above these words was an image of Santa in a sleigh being pulled by—you guessed it—the Piasa Bird. True, the quality of the depiction was much better than the one I had rendered as a six-year-old, but it was my original idea, aged to perfection and rendered in a medium more sophisticated than crayons.

Brilliant, simply brilliant, I thought to myself. Now let's see whether I can garner at least partial credit for an idea that someone else has already cashed in on. I told my customer that, as a precocious six-year-old, I had crayoned a picture of Santa's sleigh being drawn across the sky by the Piasa Bird.

The customer seemed singularly unimpressed by my revelation. "Well," he said, "it looks like somebody else beat you as far as marketing it." Point taken, I returned to trying to interest this man in some books that had just arrived at my shop. So what if someone else will get rich from an idea that I hatched as a kid? I thought. I'm a writer and own a used bookshop; and what could possibly be better than that?

Ironically, I never again saw a copy of that drawing, which led me to believe that it had an extremely limited press run or—even more shocking—it simply didn't sell that well. Perhaps southern Illinois just wasn't ready for that kind of radical creativity. Boy, I thought, that six-year-old of so many years ago had *really* been ahead of his time.

# Playing Santa on a Shoestring Budget

Santa Claus made numerous appearances in old southern Illinois. The jolly old elf could be seen at any number of stores and pre-Christmas events and even heard on the radio. During my Alton childhood, Clyde Wiseman of our city's WOKZ radio station provided the voice of Santa. I recall gasping in amazement at Santa's knowledge of me and other Alton children, unaware that parents had the option of contacting the station and requesting that Santa remind their progeny to eat their vegetables and clean their rooms. Clyde Wiseman eventually left radio broadcasting to serve a term as Alton's mayor from 1965 to 1969. Personally, I think portraying Santa is a good preparation for public service, since it unquestionably provides one with excellent people skills.

During the 1940s, Santa arrived on horseback at a Christmas festival in Columbia, Illinois, although he later opted for a wagon. The event, sponsored by the American Legion, also featured a cedar tree that had been set up on Main Street plaza near the Doughboy statue. Santa gave oranges and bags of candy to everyone in the crowd.

Caroling was also a big part of Columbia's Christmas celebration. St. Paul's Evangelical and Reformed Church brightened the holidays by organizing children and adults to sing in front of the homes of shut-ins and the sick. The children were rewarded with oranges, candy and nuts, while the adult carolers received some Christmas wine.

My mother, a child in the 1920s, shared her memories of Santa with me. They gave this writer a much different perspective on that storied decade than the one he had acquired from books and films. When asked about the Roaring Twenties, most Americans respond with references to flappers, jazz and the speakeasy nightclubs. College kids wore raccoon coats and swallowed goldfish, while couples danced the Charleston. The nation was prosperous and at peace. Life in the 1920s was like a continuous party that didn't end until the stock market crash of 1929 that heralded the Great Depression.

For my family and many—perhaps even most—people living in southern Illinois, however, the 1920s were a hard time. The Great Depression that gripped America a decade later wasn't all that distinguishable from the 1920s for them. The alleged prosperity of that dazzling epoch never managed to trickle down to our region's farmers and laborers.

My mother's family was never poor in the sense of lacking basic shelter or wondering where its next meal was coming from. The bare necessities were always there—but little else. For instance, my mother's family once dwelled in a home in Alton that had a wood-burning cooking stove, which kept the kitchen warm and toasty year round, including the dog days of summer. During winter, however, the stove's heat-generating capacity was much appreciated, since the house lacked a furnace. To keep warm, one simply dressed in layers and slept at night under a copious number of blankets and quilts. Mom's Aunt Helen, who lived with the extended family under this roof, remarked each winter that sleeping inside this house at least kept the snow from hitting one in the face.

As a child, my mother had to forego the creature comfort of warmth during the holiday season, but thanks to the efforts of her Uncle Joe, she was afforded the luxury of a personal visit from Santa Claus. Perhaps there was a Santa Claus at one of the downtown Alton stores, but Uncle Joe was the kind of man who liked to do things himself. Whether he was particularly good at the task at hand was always irrelevant. Uncle Joe once told me that he was such an expert handyman that he could take a clock completely apart, put it back together and still have three or four parts left over.

# Christmas

Playing Santa one Christmas for my mother and her cousin, who lived next door to my mother's family, presented a problem for Uncle Joe that would have intimidated a lesser man. He and the other adult family members didn't have the funds necessary to rent a Santa Claus outfit. Uncle Joe was the kind of fellow who appreciated such a challenge, however, so he transcended this difficulty with typical Irish ingenuity. He simply improvised by using the materials that were at his disposal. Unfortunately, any resemblance between Uncle Joe's costume and Santa Claus was purely coincidental.

Since he could neither borrow nor buy garments similar to Santa's traditional red and white outfit, Uncle Joe simply chose to discard that part of the tradition. His ordinary clothes were concealed by a long, heavy overcoat he had borrowed from a friend. Uncle Joe lacked a beard, and exercising the kind of frugality required of those with low incomes, he decided to play a clean-shaven Santa. To prevent my mother and her cousin from recognizing him, he donned a cheap plastic false-face that might have been discarded by a Halloween trick-or-treater. An old hat completed Uncle Joe's Santa outfit.

Anyone outside the family who saw Uncle Joe in this getup would have assumed that, rather than the beloved bringer of Christmas gifts, he was a bank robber who had donned a disguise before attempting to pull off the biggest heist of his career. Aunt Helen, just fourteen years older than my mother and already recognized as the family wit, took delight in noting the contrast between the rotund figure of the traditional Santa Claus and Uncle Joe's skinny physique. "It looks like Santa's had a pretty hard year," she quipped.

Uncle Joe decided to surprise my mother and her cousin when they were at the cousin's house. He saw them seated at the kitchen table and tapped on the window while crying, "Ho! Ho! Ho!" at the top of his lungs. The distinctive Santa greeting was not sufficient to identify this bizarrely dressed person as Good St. Nick to the children. My mother told me that, while she was undeniably scared, her cousin became so terrified that she leaped from her chair, scurried across the table and threw both arms as tightly as she could around her father's neck. "I can still hear him yelling, 'Let go, Faye, let go of me!'" mother said. She also insinuated that Faye's father uttered some additional words that she was reluctant to repeat.

Fortunately for all parties concerned, Faye's mother then entered the kitchen and proclaimed in that artificially cheery voice that adults sometimes employ when dealing with difficult children, "Oh look, it's Santa Claus!" The children immediately connected this pronouncement with the telltale "Ho!" salutation in triplicate and decided that the strange figure was, in fact, Santa and not some boogeyman with designs to carry them off to heaven knows where. By the time Uncle Joe entered the kitchen through the back door, my mother and Faye no longer had the urge to run and hide.

Uncle Joe followed the script employed by all Santa Clauses as he conversed with the girls by asking whether they had been good and what they wanted for Christmas. He departed chirping another triplicate "Ho!" and had succeeded in winning my mother and cousin to such a degree that they actually felt privileged to have enjoyed a private audience with Santa.

My mother and Uncle Joe always brought up this episode each Christmas. He joked about the ragtag Santa costume he had assembled, while mother assured everyone listening to the conversation that no child or adult would ever have guessed that the person wearing an overcoat and false face was supposed to be Santa. Faye also remembered the incident but remained strangely silent about allegedly almost choking her father to death.

As a child, mother took me to visit Santa Claus when he appeared at the department stores that once lined West Third Street in Alton. His suit was always resplendent. His snow-white beard was so wide and fluffy that birds could have nested in it. But when I grew older and mom told me about the year Uncle Joe played Santa for her and Faye, I felt that those two long-ago children had enjoyed a Christmas blessing that I had never known. The Santas upon whose laps I had sat as a little boy had been paid by department stores to play St. Nick. Uncle Joe's sole motivation had been his love for his niece and her cousin. Men like that surely make the best Santas.

# Christmas Gifts

M any people think that, since southern Illinois is a primarily rural region sprinkled with a few small towns and cities, Christmas gifts in years past surely must have consisted of corn shuck dolls and hand-carved cup and ball games. While pioneer-era families indeed might have exchanged such presents, late nineteenth- and twentieth-century southern Illinoisans with the means to do so purchased their gifts at stores, just like other Americans. Relatives—especially children—were treasured, and we wanted to give them items that let them know it. If times were especially hard, homemade gifts might have to do, but southern Illinoisans knew that the best presents came from stores.

My mother's family were people of extremely modest means, but she always received gifts that had been purchased from downtown Alton. Her most treasured Christmas present was a doll named Ann. Although I never saw Ann, I heard so many stories about her that I came to feel she was some long-lost relative who one day would show up at our front door and receive a warm welcome.

Ann was my mother's first real doll, a gift from Santa on Christmas 1922, although mom was a little shaky on the date. She might have had a porcelain head, another claim that mom sometimes wavered on. My mother *was* certain, however, that Ann had blonde hair, blue eyes and came garbed in a lovely white dress. Ann and my mother were constant companions and the best of friends.

Mom was a notorious saver of things, which meant that the attic, basement and closets of our family home were crammed with memorabilia. Her childhood scrapbook, coin purses from long-dead relatives (with the coins still in them), Aunt Dot's wedding dress from 1923 and countless other mementos were duly preserved for future generations. Ann, however, was conspicuous in her absence. Sometime in the 1920s—again, mom was unsure about the exact year—her childhood home caught fire, and many of their possessions perished in the blaze, including mom's beloved Ann.

Still, a few things were saved, including a Christmas gift mom had received just one year after Santa brought her Ann. Ironically, this particular salvaged item had belonged to Ann. It was nothing particularly fancy, mind you: just a ten-inch by twelve-inch cloth that bore the image of a rabbit named Esmond.

Today, only toy collectors and a few scholars of American social and business history are familiar with Esmond. In his heyday of the 1920s, however, this imaginary rabbit enjoyed the kind of popularity later generations of children would bestow upon Barney the dinosaur and Pokemon characters. Esmond was the creation of the long-defunct Esmond Mills Company of Rhode Island. Although children of that era loved Esmond with a passion, there was nothing even vaguely altruistic about this little squirt. He was created and marketed by Esmond Mills for the sole purpose of making money for the company.

America was flooded with copies of a free pamphlet titled "The Story of Bunny Esmond," written by Harry M. Kidd. Esmond's magnificent coat of fur made him the envy of Reddy Fox, who lured the rather naïve rabbit to his lair. Reddy Fox then accused him of taking way too much pride in his fur and decided to teach him a lesson in humility by shearing Esmond. Now chilly and more than a bit embarrassed by his naked state, Esmond covered himself with a bunny blanket.

By a strange coincidence, Esmond Mills manufactured a "bunny blanket" that was a dead ringer for the one worn by Bunny Esmond. A fine image of Esmond adorned this pink cloth, which also bore Esmond's name so that children and their parents couldn't possibly mistake any other bunny image on a cloth for *this* one. While "The

Story of Bunny Esmond" pamphlet was free, his bunny blanket was not. By a strange coincidence, stores that carried the pamphlet always had Esmond's bunny blanket in stock.

Mom evidently read "The Story of Bunny Esmond" and decided that this blanket would make a great addition to Ann's wardrobe for Christmas. Santa became aware of her wish and cooperated by leaving a blanket at mom's home. I have no idea how much it cost, but every cent counted for my mom's mother and her relatives. They found it financially easier to survive if they lived under one roof rather than multiple roofs. My mother's parents had divorced when she was a baby, and mom was the only child in the household. One of mother's relatives might well have gone without something just so she could have the bunny blanket.

My mother missed Ann but cherished that blanket as a reminder of her beloved first doll. My wife and I proudly display Esmond's blanket in our home. Mom was a great one for preserving the history of our family's heirlooms and often wrote notes that she attached to

This Bunny Esmond doll blanket belonged to the author's mother in the 1920s.

them. The bunny blanket has a note attached to it by an old safety pin. This was her first doll blanket and dates from 1922, mom's printing reads. When visitors to our house ask about the dark stains on the blanket, I tell them that those are scorch marks from a long-ago fire.

Her childhood poverty, as well as losing Ann in the house fire, must have made my mother determined that her son—her only child—would have an abundance of Christmas presents every year. As her only grandchild, my maternal grandmother made me the object of her adoration. Aunt Dot and Uncle Joe were childless, which tended to work in my favor as well. I always made out pretty well on December 25.

I inherited mom's propensity for saving things, including a number of long-ago Christmas presents that I now spot in antique stores. My Lionel train set, complete with stoplights and railroad crossing signs, proudly graces the top of a bookcase in my study. Several wind-up toys, one still in its original box, catch the eyes of visitors who can't believe that they still work after so many years. Well, mom taught me to take care of my things!

The most curious Christmas gifts I received as a child came from someone I had never met, although he was quite the local celebrity. One of his employees personally delivered a wrapped present to my home shortly before Christmas. It wasn't until many years later, when I began studying local history, that I came to realize just how unusual—and controversial—it had been for me to receive a holiday gift from this person.

My maternal grandmother, who lived with us, worked as a police matron. Her duties included using the police radio to dispatch squad cars and searching women who had been arrested and brought to the police station. The Christmas gift I received each year came from a man who was acquainted with my grandmother and knew that she worked in the Alton Police Department. Ordering one of his employees to purchase a present for her grandson and having it delivered to the house that she shared with this lad and his parents was this gentleman's way of showing his respect for Alton's Finest.

Who was my once-a-year benefactor? Although he has been deceased for many years, discretion dictates that I withhold his name.

He was part of Alton's underworld and operated an establishment on East Broadway where men could gamble and enjoy brief intimacy with attractive young women.

Did he also send a Christmas gift to my grandmother? If so, I never learned about it. Did the children and grandchildren of other city employees receive Christmas presents by special messengers? I have no idea. I am equally clueless as to how my grandmother, who was a devout Catholic, came to know such a person. Grandma was scrupulously diligent in the performance of her official duties, even at the cost of many a good night's sleep. When a female suspect needed to be searched in the wee hours of the morning, a squad car was dispatched to our home to pick up grandma.

It is a well-documented fact that the Alton of years past was what is euphemistically referred to as a wide-open town, where gambling and prostitution flourished. Uncle Joe told me that a "gambling parlor," as he called it, existed just down the street from the newspaper where he worked. The gentleman who sent me a Christmas present each year was hardly a lone wolf in his criminal pursuits. One may assume that such enterprises would have found it difficult to exist, let alone thrive, without having reached some kind of accommodation with police and city government.

In any event, I continued to receive my Christmas present until I was about fourteen. I don't know why they suddenly ceased. Perhaps my benefactor died, retired to Florida or simply decided to turn over a new leaf. While I indeed appreciated his annual gift as a small child, it became something of a family joke as I grew older. Each year, this gentleman must have instructed an underling to buy a gift for a child and remained oblivious to the fact that I was growing up. At ages twelve and thirteen I was still receiving toys that were suitable for a six-year-old. I began donating his gifts to needy area families at Christmas and discovered the joy of humanitarianism. Where else but in southern Illinois could a gangster enable a kid to become a once-a-year philanthropist?

# Christmas Dinner
# at the Stratford

I have no childhood memories of a Christmas dinner that was held at home—either our home or that of any other relative. My mother told me that Uncle Joe decided, when I was about two, that his beloved niece had her hands full during the holiday season and didn't need the added burden of preparing a Christmas dinner. He would treat us, as well as a number of other relatives, to dinner in a restaurant.

But which restaurant? For Uncle Joe and Aunt Dot, the choice was obvious. Only Alton's Stratford Hotel was sufficiently elegant for this new family tradition.

Opened on September 4, 1909, as the Illini Hotel, the Stratford is a five-story brick structure that was designed by the St. Louis architectural firm of Barnett, Haynes and Barnett. Its floors, which consist of concrete that has been reinforced with steel, have allowed its owners over the years to tout the Stratford as utterly fireproof. The hotel's distinctive architectural features include quoin brick corners, detailed terra cotta trim, limestone panels, Gothic columns and marble staircases. Uncle Joe and Aunt Dot valued refinement and decorum, which the Stratford epitomized.

I recall that an artificial tree, trimmed with ornaments and lights, was always set up in the lobby by a window that faced Market Street. This comprised the Stratford's only Christmas decoration. No more was needed, however. This grand old hotel radiated

enough elegance in its natural state to suffice for the Yuletide or any other holiday season. The view from that Market Street window showcased downtown Alton back in its prime, long before stores began fleeing to malls or going out of business altogether. Every streetlight seemed like a festive Christmas light simply because it was framed by the Stratford window.

Besides Aunt Dot, Uncle Joe and myself, the Christmas dinner guest list included: my parents; my maternal grandmother (Uncle Joe's sister); my mother's cousin, Faye, and her husband; and several cousins from Aunt Dot's side of the family. My father was a reluctant, even defiant, member of our group. An electrician's helper at the Shell Oil Refinery in Roxana, dad's roots were firmly entrenched in the working class. Dining at the Stratford meant venturing into Uncle Joe and Aunt Dot's solidly middle-class world, a world that my father found mysterious and menacing. Upon returning home from dinner, dad would rave about the poor service, lousy food—his list went on and on. One Christmas he flat-out refused to attend the Stratford dinner and dined alone at home on refrigerator leftovers. When mom, grandma and I returned home, he heatedly asked us how long it had taken for us to be served. Then, without waiting for a reply, dad told my mother to phone Aunt Dot and Uncle Joe to tell them that the Christmas dinner tradition at the Stratford should be discontinued. Needless to say, mom did not comply, and dinner was held at the hotel the following Christmas, although I don't remember whether it included dad.

My father's dislike of all things middle class blinded him to the truth that the Stratford's food was reasonably tasty and its service at least adequate. But all of that was really beside the point. For me and the others who gathered at the table, it was all about a chance to celebrate a sacred holiday together in an Alton landmark. The dinner fare could have been hamburgers and fries served by a slow dinosaur. We came together to enjoy one another's company and warm ourselves in the glow engendered by family fellowship. We came together to rekindle our love for one another.

My most cherished experience at our Stratford Christmas dinner is known to me only through my mother's recollections. It occurred when I was just three. According to mom, the dining room had a

piano that Christmas, so Uncle Joe and I entertained the guests with an impromptu rendition of "Chopsticks." Since I have no memory of this performance, I must rely on mom's account that our playing left much to be desired. Its conclusion was met with applause, either out of mechanical politeness or—more likely—sheer relief that this unscheduled concert was over.

I *do* recall, however, that my family often referred to this event. Aunt Dot, according to the general consensus, had gently admonished Uncle Joe for instigating it, while my father had become angry and vowed that I would never again attend Christmas dinner at the Stratford. Mom also concluded her narrative of this incident by noting, "Of course, you were right there with us next year."

The Stratford Christmas dinner tradition continued after Uncle Joe's death in 1981, although with diminished enthusiasm. He had been such a strong presence, helping us along life's journey so often. How we missed him! Our Christmas family further decreased as some of Aunt Dot's relatives moved away and couldn't return for the holidays. The 1985 dinner included just six or seven people, a far cry from the twenty or so from years past. I treasure the memory of that dinner all the more now, since it was our last. Aunt Dot died in 1986, and our dinner tradition died with her.

No Christmas dinner during the ensuing years was as memorable and heartwarming as the Stratford gatherings—with one poignant exception. The year 2004 had not been kind to me. Divorce and bankruptcy had left me emotionally wounded and bereft of the funds necessary to treat my mother to Christmas dinner at a good restaurant. Mom, a widow since 1993 and an only child like me, had no relatives with whom she could dine. Preparing a lonely meal for two at her home on what is supposed to be the most joyous day of the year didn't appeal to either one of us.

Then I had an idea. The College Avenue Presbyterian Church in Alton, the same church where the martyred abolitionist newspaper editor Elijah Lovejoy once served as pastor, offered a free Christmas dinner on the afternoon of December 25 to anyone who showed up. The organizers call the people who dine in the church's fellowship room their Christmas family: an eclectic assembly of those experiencing economic hard times, including couples with

children; single people, like my mother and myself, who are without relatives; and area residents who simply want to dine with some truly wonderful people on Christmas. I told mom about the church dinner and assured her that we'd be in good company. She agreed, and we drove to College Avenue Presbyterian Church about a half hour before the 2:00 p.m. dinner so that we could socialize with the other members of this Christmas family.

The diners indeed were from all walks of life and included some people known to my mother and me. While the church's fellowship room was a far cry from the Stratford in those years when the old hotel was in all its glory, the friendliness and sheer warmth of our fellow diners rivaled the ambience we had known so long ago. Mom and I were again part of a family. True, the members of this family bore different last names, but that didn't matter. We were united by the bond of love that permeates the season of Christmas.

The food, which included double-digit numbers of turkeys and hams, was delicious and served buffet style. Mom laughed when I remarked that we got something to eat here much faster than at the Stratford. The event even included a visit from Santa, and we enjoyed watching the little ones squeal with delight as they unwrapped their presents. Mom and I were among the last diners to leave. We were just having too much fun to make an early exit.

This was mom's last Christmas. She died in the fall of 2005, just as stores were beginning to jump the season again by setting up holiday decorations. I will always be grateful to College Avenue Presbyterian Church, the dinner's organizers and our 2004 Christmas family for helping to make her final Yuletide so happy. I now enjoy Christmas dinner with my wife and in-laws, where I again experience the joy of holiday fellowship with loved ones. Mom, Aunt Dot and Uncle Joe would be so happy to know that.

# A Deutsche Christmas in Southern Illinois

As a child, I always rather envied a family of German descent that lived in Godfrey, which was still an unincorporated area of farms and a few subdivisions when I was a child. That family's children received presents on *two* days during the holiday season. Santa's descent down their home's chimney during the waning hours of Christmas Eve was always preceded by an earlier event of no less miraculous proportions—a visit from St. Nicholas.

On December 5, the eve of St. Nicholas's feast day in the liturgical calendar of the Roman Catholic Church, the family's two children hung their stockings by the fireplace. They awoke the next morning to find the stockings overflowing with candy and small gifts. Santa Claus, of course, was no piker. He paid the children a visit late on December 24 and left larger presents beneath the Christmas tree. Santa put nothing in the stockings, however, since they had been put away. Filling stockings was the exclusive prerogative of St. Nicholas, and he wouldn't return to this southern Illinois household until December 5 of the next year.

For most Americans these days, St. Nicholas and Santa Claus are virtually synonymous. We know that Nicholas, a sixth-century bishop of Myra located in what is now Turkey, is a saint of the Roman Catholic and Eastern Orthodox Churches whose feast day is December 6. He is the patron saint of Greece, Russia and sailors of all nations. Nicholas is said to have performed any number of

miracles, but it was a simple act of compassion that secured his reputation as one who bestows gifts.

A poor man had no dowries for his three daughters, which meant that they could never marry and probably would be doomed to prostitution. Nicholas wished to help the unfortunate father but without attracting attention to himself. He went to the man's house one night and threw three bags of gold coins—one for each daughter—through an open window. A tradition of gifts brought at night by the kindhearted St. Nicholas had been born. The church's proclamation that St. Nicholas was the patron saint of children helped to establish the bishop as the benefactor of boys and girls everywhere.

The custom of receiving gifts from St. Nicholas was particularly popular in Germany. The Protestant Reformation wasn't kind to the good bishop in northern Germany, where Lutheranism uprooted St. Nicholas Day, along with all the other saints' feasts days. Roman Catholicism remained dominant in southern Germany, however, and states such as Bavaria celebrated St. Nicholas Day with all the vigor of olden days.

On the eve of St. Nicholas Day, children cleaned and polished their shoes until they could see their reflections in them. The shoes then were placed outside or left under the children's bed. In the morning, children who had behaved well during the preceding year discovered candy and other treats in their shoes. Naughty children, however, awoke to find a lump of coal.

St. Nicholas even made personal appearances in some villages and towns. A bearded man garbed in a flowing robe, wearing a bishop's miter and carrying the traditional staff of a bishop, called on households with children on the eve of St. Nicholas. He rode a white horse or a donkey and sometimes was accompanied by Ruprecht, his servant. An ugly, decidedly intimidating figure, Ruprecht played what we would call the bad cop to St. Nicholas's good cop. The bishop would ask children whether they had been good. If a guilty conscience made any child's reply of "Yes, dear St. Nicholas" sound somewhat unconvincing, the bishop would threaten to give the child to Ruprecht if the misbehavior continued.

I talked with a southern Illinois woman whose German-descended family observed this St. Nicholas Day tradition. A

neighbor, dressed in what passed for a bishop's clothes in their farming–coal mining community, visited homes with small children. She recalled that the beloved St. Nicholas indeed was accompanied by the sinister Ruprecht.

Another woman who was present immediately asked, "Don't you mean Black Peter?" She, too, was German Catholic–descended, and while her family didn't welcome St. Nicholas into their home on December 6, she knew the bishop's grim companion by a different name. In some regions of Germany, Ruprecht was called Black Peter, while children in other parts of the country referred to him as Pelznickel. Whatever his name, however, his role was the same: St. Nicholas's menacing counterpart.

St. Nicholas Day was also observed by the Catholic community in Holland, where it was immortalized in a wonderfully evocative painting by Jan Steen in 1666. Titled *Hes feest van Saint Nicholaas* ("The Feast of St. Nicholas"), the work depicts a Dutch family at home on December 6. A little girl, her face radiating joy, is cradling a doll she received as a gift from St. Nicholas. Her brother, however, is crying, presumably because St. Nicholas left no present for him.

It was formerly believed that Dutch settlers who immigrated to the New Netherlands and its capital, New Amsterdam (both later renamed New York when Great Britain wrested control of the colony from Holland), brought the St. Nicholas Day tradition with them to America. Scholars now know this was not the case. While *Hes feest van Saint Nicholaas* was indeed celebrated by Dutch Catholic families, as depicted in Steen's painting, the New Netherlands colony was settled by Dutch Protestants who wanted nothing to do with what they saw as "Catholic saint worship."

So how did Saint Nicholas establish that initial foothold in the New World? Rather than riding piggyback with Dutch immigrants to New York, Old St. Nick was deliberately reinvented by three wealthy New York patricians: Washington Irving, John Pintard and Clement Moore. Of old Yankee stock rather than Dutch, it is no exaggeration to state that these men created St. Nicholas/Santa Claus as Americans know him today.

Washington Irving, who later would do so much to idealize the celebration of an old-fashioned English Christmas with his account

of the fictional Bracebridge family in *The Sketch Book*, wrote a book with one of the longest and most unusual titles on record: *A History of New York from the Beginning of the World to the End of the Dutch Dynasty, Containing Among Many Surprises and Curious Matters, the Unutterable Ponderings of Walter, the Doubter, the Disastrous Projects of William the Testy, and the Chivalric Achievements of Peter, the Headstrong—The Three Dutch Governors of New Amsterdam: Being the Only Authentic History of the Times That Ever Hath Been, or Ever Will Be Published by Diedrich Knickerbocker.* Published in 1809, this work is usually referred to simply as *Knickerbocker's History of New York.*

Although set in old New Amsterdam, *Knickerbocker's History of New York* actually satirized the city as it was during Irving's day. He claimed that the Dutch paid special homage to St. Nicholas for guiding them to the site and consecrated a chapel within the fort to the good saint. For his part, St. Nicholas supposedly placed New Amsterdam under his care, where he "often made his appearance in his beloved city, of a holiday afternoon, riding jollily among the tree-tops, or over the roofs of the houses, now and then drawing magnificent presents from his breeches-pockets, and dipping them down the chimneys of his favorites. Whereas in these degenerate days of iron and brass, he never shows us the light of his countenance, nor visits us, save one night in the year, when he rattles down the chimneys of the descendants of the patriarchs, confining his presents merely to the children."

*Knickerbocker's History of New York* contains about twenty-five references to St. Nicholas. Undoubtedly the most interesting has the saint "laying a finger beside his nose," a phrase that would later find its way into Clement Moore's poem "A Visit from St. Nicholas." Irving chose to have *Knickerbocker's History of New York* published on St. Nicholas Day in an effort to popularize this saint among contemporary New Yorkers.

Like Pintard and Moore, Irving was an arch-conservative who intensely disliked the Jeffersonians and their democratic ideals, which he regarded as contributing to the vulgarization of American society. Nonetheless, this traditionalist contributed an innovation to the St. Nicholas legend by portraying the good bishop as flying through the air and dropping presents down chimneys.

John Pintard, like many other wealthy New Yorkers, was disturbed by the rowdiness that characterized the celebration of Christmas. Gangs of young toughs, often intoxicated, roamed the city and made "music" with penny whistles and makeshift drums. If these revelers had confined their activities to the poorer sections of town, Pintard and the well-to-do wouldn't have minded. But they brazenly invaded the neighborhoods of the wealthy, vandalizing property and disturbing the slumber of the governing classes.

Pintard recalled from his youth the genteel celebration of Christmas, when rich and poor mingled freely without fear of violence. The consumption of spirits had comprised a vital facet of that celebration. Indeed, Pintard, writing in 1827, noted that he and a family servant in days gone by had traveled about the city in what he euphemistically termed a "boisterous" manner, drinking a dram at every stop. Drunkenness among the laboring classes, however, made it dangerous for well-bred gentlemen to venture out during the Yuletide—particularly, we might add, when said gentlemen were also inebriated.

Since observing the Yuletide now demanded temperance for the well-to-do, Pintard decided that observing certain customs might enhance their enjoyment of the holiday season. Why not try the German and Dutch tradition of St. Nicholas Day? Pintard thought.

In 1810, Pintard paid the acclaimed illustrator Alexander Anderson to create a broadside about St. Nicholas, which Pintard distributed to his friends and fellow members in the New York Historical Society. The image of St. Nicholas portrays him in a bishop's garb and notes that his feast day is December 6. The broadside also includes a poem that is written from the perspective of a child. The poem concludes with the young one promising to serve St. Nicholas if the good bishop will give the child a gift.

In addition to the depiction of St. Nicholas, the broadside also shows two children, a boy and a girl, standing on the mantel of a fireplace. The girl is smiling because she holds an apron filled with fruit while looking down on a stocking brimming with toys. The boy, however, must have been naughty. He is crying and holds a switch, while his stocking is crammed with enough switches to last his parents the entire year.

It is significant to note that St. Nicholas left his gifts for the children in their stockings, not in their shoes. St. Nicholas was now in the process of being transformed into the modern Santa Claus.

Pintard was determined to popularize December 6 as a holiday in the United States and held elaborate St. Nicholas Day banquets for the New York Historical Society. Despite his best efforts, however, the holiday failed to catch on. Americans who observed St. Nicholas Day, such as the Godfrey family of my childhood, celebrated it because their ancestors had brought the custom with them from Germany.

This was Pintard's only failure in creating a beloved annual celebration. He played a vital role in establishing George Washington's birthday, Columbus Day and the Fourth of July as national holidays. Undeterred by his St. Nicholas Day experience, Pintard also worked to popularize Christmas Day as an American holiday.

Clement Moore, another New Yorker and historical contemporary of Pintard and Irving, wrote the beloved classic "A Visit from St. Nicholas" in 1822, but the only similarity that Moore's title character bears to the saint of German and Dutch tradition is his name. A jolly old elf rather than a Catholic bishop, Moore's St. Nicholas rewards good children on Christmas Eve rather than December 6. Like Irving's St. Nicholas in *Knickerbocker's History of New York*, he flies from rooftop to rooftop and slides down chimneys to deliver his presents. The German-Dutch tradition of a ghostly bishop who rides a horse or donkey from house to house seems rather mundane by comparison.

I am not acquainted with any southern Illinois families that still observe the St. Nicholas Day tradition. The saintly bishop of old has been eclipsed by Santa Claus, and December 6 is simply another day in the countdown to Christmas. I still remember, however, my envy for those long-ago Godfrey children who received presents on *two* December days from *two* supernatural figures. St. Nicholas Day is a tradition that begs to be revived. Remember, parents—your children will grow up only all too soon, so give them another day of magic.

# Christmas at the Jarrot Mansion

Christmas—or *Noël*, as the French called it—was observed rather than celebrated in early Illinois towns such as Cahokia, Kaskaskia and Prairie du Rocher. A *creché* (Nativity scene) typically occupied a conspicuous spot in every home, and parents reminded their children of the day's sacred significance.

The young ones received treats, however. On *Noël* eve, they would leave their shoes by the fireplace and awaken the next morning to find them filled with fruit, nuts and candy that had been left—not by Santa Claus—but by *le petit Jésus*, the Christ Child himself.

Christmas at the Jarrot mansion in Cahokia was the archetypal *Noël* in early southern Illinois. Born in France in 1764, Nicholas Jarrot (sometimes spelled Jarreau) immigrated to the New World at the age of twenty-six. He landed in Baltimore, spent time among the French expatriates of New Orleans and then journeyed up the Mississippi to the old Gallic town of Ste. Genevieve, where he lingered for three years. He then moved to Cahokia, put down roots and opened a store to engage in the fur trade. Jarrot later invested in real estate and became one of the wealthiest men in the Mississippi Valley. At one time, Nicholas Jarrot owned as much as twenty-five thousand acres of land in the fertile American Bottoms.

As the scion of an old aristocratic family, Jarrot took pride in his French heritage and wanted to maintain a Gallic line. His first wife was Marie Barbeau of Prairie du Rocher, by whom he had a

daughter, Elise. When Marie died, he married Julia Beauvais, whose family settled in Ste. Genevieve after leaving Kaskaskia.

The Beauvais family was wealthy by French New World standards. The possessions Julia brought with her to Cahokia included a silver ladle and cups, trousseau gowns from France and even cloths of gold. An old account claims that Julia wept upon leaving her parents' comfortable home in Ste. Genevieve for Jarrot's small frame house, located across the street from Cahokia's St. Sulpice Church of the Seminary of Foreign Missions. But Jarrot was an intensely ambitious man and commissioned the building of a mansion that stands to this day.

Begun in 1799 and not completed until 1806, the Jarrot mansion might well have been the first brick home in the entire Mississippi Valley. No expense was spared. The Jarrot mansion featured windowpanes and frames that were imported from France. Laborers used wooden pins, rather than nails, in their work and constructed a huge fireplace on the western wall.

Daily life in the mansion embodied the aristocratic ideals that defined men such as Nicholas Jarrot. Like many of the old French families, the Jarrots held slaves. During the humid Mississippi Valley summers, slaves wielding huge fans kept the air circulating in the mansion when the Jarrots entertained guests.

The Jarrot mansion became the social center for Cahokia and its neighboring communities. Elegant balls, beginning at "candlelight," as early settlers called dusk, and concluding at

The Jarrot mansion in Cahokia was completed in 1806 and could well be the first brick home in the Mississippi Valley.

midnight followed one another in rapid succession. The house rang with laughter and music.

Jarrot had seven children by his second wife, and these youngsters surely delighted in the treats left in their shoes by *le petit Jésus*. Like all Catholics at that time, the Jarrots fasted before receiving communion at midnight Mass on Christmas Eve. Upon returning home, *Fête de Noël* (the Feast of Christmas) began with *Réveillon*, which was an enormous early Christmas morning breakfast for family and friends. Hot spiced cider, brandy-laced eggnog, sausages and baked eggs comprised the traditional fare of *Réveillon*. As the home of the premier family of Cahokia, the Jarrot mansion saw many guests each Christmas for *Réveillon*.

The Jarrots entertained frequently, but their *Bal des Rois* (Kings' Ball) dwarfed all other social events held during the holiday season. The details of this ball, held on January 6, are dealt with in the Twelfth Night section of this book. While the reenactment Kings' Balls that we know today certainly feature the songs, dances and Kings' Cakes of an earlier era, there is one facet of traditional *Bal des Rois* that is always missing. The Jarrots knew that some men— particularly elderly men—do not enjoy dancing, so a room was always set aside for the playing of cards.

It seems that Frenchmen of the Illinois colonial district were so passionate about card games that a room in almost every house— including the Jarrot mansion—was devoted solely to this pursuit. While gaily dressed couples danced and made merry at the *Bal des Rois*, many men passed the time by playing cards. Their favorite game, according to one old source, was *vingt-un*, the game we know as twenty-one or blackjack.

Nicholas Jarrot enjoyed cards. Like many wealthy men of his era, he kept large sums of money in his home. He stored silver coins in a large horsehair chest, while a red trunk held his gold coins. As a man of honor, Jarrot promptly paid his gambling debts by dispatching a slave to retrieve the necessary number of coins. This freed Jarrot from having to leave the card game.

The gala season at the Jarrot mansion began at Christmas and did not conclude until Shrove Tuesday, which we know better as Mardi Gras. Fat Tuesday was known as Shrove Tuesday in years past, since Catholics viewed it as a time to be shriven from one's sins by confessing

The interior of the Jarrot mansion embodies the elegance of a bygone era.

them to a priest and receiving absolution in preparation for Lent. Shrove Tuesday was also called Pancake Tuesday because French families traditionally make great quantities of pancakes to use up butter and other foods that were forbidden to the faithful during Lent. Guests at the Jarrot mansion feasted on these pancakes that were prepared by slaves who had been taught the fine art of preparing French cuisine.

The following day, Ash Wednesday, marked the beginning of Lent. As devout Catholics, Jarrot and his family would have had ashen crosses traced on their foreheads as a reminder of humanity's mortality. The revelry that began at *Noël* finally had come to an end. Nicholas Jarrot died in 1820. As the nineteenth century progressed, his children gradually relocated to St. Louis to take advantage of the greater economic and cultural opportunities afforded by that much larger city, which also had been founded by the French. With the death in 1886 of Ortance, Jarrot's eldest child by his second wife, the Jarrot family's residence in the mansion came to an end, although they retained ownership of it for use as a summer house to escape the heat of St. Louis. In 1905, however, the family sold the home to Cahokia's Holy Family Parish, and the old mansion became a school.

The State of Illinois acquired the Jarrot mansion in 1980 and allows the public to tour this historic treasure. Using just a little imagination while walking through its rooms, one can almost smell the aroma of *Réveillon* and hear the music of *Bal des Rois*.

# Birds of Christmas

Anyone taking a December walk through southwestern Illinois might well see a huge flock of robins. Unlike migratory birds, most robins in this area spend the winter months here. Typically, they gather in low, damp areas such as creeks and marshes to ride out the blizzards and ice storms. That "first robin of spring" we rejoice upon seeing in our backyards is simply an adventurous bird that has departed from one of these winter flocks.

I know a woman who spotted a flock of approximately two thousand robins in Godfrey on Christmas Day 2008. Someone, such as myself, who revels in Yuletide customs and legends would have rejoiced at such a sight. Robins have an old association with Christmas and were the subject of a story told during holiday seasons of years past.

It was said to be particularly cold on the night when Jesus was born in that Bethlehem stable. Joseph and Mary possessed no fire and asked the innkeeper, who had consigned the penniless couple to the stable when they couldn't afford to rent a room, for a lighted candle so they could start a small campfire for warmth. He summarily refused.

When returning to the stable, Mary noticed a robin perched by the door. She asked the bird to bring her a bit of fire, and it quickly flew away. When the robin returned, its beak held a tiny burning brand that Mary used to start a small campfire. The brand's flame had burned

the robin, however, and its breast feathers were now red. Mary asked God to let all robins now have red breasts so that everyone would know how this robin had kept the Holy Family from freezing to death in the Bethlehem stable on the night that Jesus was born.

It's a lovely legend, but most people don't associate the robin with Christmas. That distinction belongs to another bird—the cardinal, or "redbird," as my father always called it. The cardinal is the state bird of Illinois and beloved the year round in my family, but never more so than at Christmas.

I recall my parents' joy upon receiving a Christmas card that depicted a cardinal perched on a snow-laden evergreen branch. That was the card they displayed atop my long-deceased great-great-uncle's roll-top desk, where it was clearly visible to anyone who visited our home. Cards that didn't feature cardinals were treated with respect, to be sure, but usually relegated to a decorative basket my mother placed on a marble-top table, which was also a legacy from that Irish immigrant. Both pieces of furniture were cherished as family heirlooms, but it was generally understood that the roll-top desk was reserved for items of weighty significance—such as Christmas cards that featured cardinals.

My parents always made sure we had a large quantity of sunflower seeds during the winter months so that our neighborhood's cardinals hopefully would never know hunger. Tossing these seeds into the backyard was a morning ritual, but it was never more reverently observed than on Christmas Day. Mom always said that it brought good luck to see cardinals on Christmas morning. As I grew older, I'd answer that it was hardly challenging for us to see redbirds in our backyard on that morning or any winter morning, since we lured them to our yard daily with sunflower seeds.

Snow on the ground at Christmas certainly made Bing Crosby's holiday classic more meaningful when it played on the radio, but we kept our fingers crossed for the white stuff because it made a more resplendent backdrop for our cardinals than bare, ugly ground. Even the female redbirds, with their muted tone, seemed to glisten when offset by fresh, clean snow. I remember Christmas mornings when as many as twenty cardinals, male and female, feasted in our small backyard while my family watched from two kitchen windows.

Dad was the oldest of six children born to an oil refinery employee father and housewife mother. He earned money as a boy by carrying newspapers and caddying at the golf course of our city's country club. Drafted into the army during World War II, he was sent to Europe and awarded a Purple Heart when he was injured by an artillery shell. Dad bore no physical scars, but like so many veterans of every war, his emotional scars were deep and abiding.

Although it often was difficult for my father to find joy in life, feeding his beloved redbirds was Dad's passion. The man who cared little for holidays or even his own birthday delighted in watching cardinals feast on the sunflower seeds that he bought for them with the same regularity that he purchased groceries for his family. Dad would sprinkle sunflower seeds in the backyard before leaving for work as an electrician's helper at the same oil refinery where his father was killed in an industrial accident in 1942, just before dad was shipped out to Europe. He then waited for a cardinal to show up. If one arrived before he had to leave for work, dad felt a bit happier.

Dad died on January 29, 1993, at age seventy-six. My mother had given up driving some years before and was dependent on me for transportation when she wanted to visit his grave. When we went to the cemetery on Christmas Eve of that year, we brought some sunflower seeds with us. The specially designed evergreen wreath we had placed on dad's grave earlier in the month was still beautiful and even featured a cardinal figurine. But we wanted to try to give dad the real thing as our Christmas gift to him. I sprinkled the sunflower seeds over the length of his grave while mom wept softly.

Mom and I knew that not even the hungriest redbird would make an appearance with us standing there, so we walked away from Dad's grave. We never looked back to watch for a cardinal but felt certain that at least one alighted to sample those sunflower seeds on Christmas Eve or Christmas Day. How dad must have appreciated that.

# Plants of the Season

Our next-door neighbors sent my wife and me a rosemary shrub that had been trimmed to resemble a small Christmas tree. "Rosemary trees" have become popular Christmas gifts over the past few years, and understandably so. Their fragrance is delightful, and they nicely complement the Christmas tree in adding indoor greenery to one's house.

I've heard people congratulating whoever came up with this swell idea of marketing rosemary as a Yuletide accessory. They have no inkling that rosemary was a vital part of an old English Christmas celebration for centuries and that some people—such as this southern Illinoisan—have made this herb part of their holiday celebration for many years.

During the Middle Ages, rosemary was on par with holly, ivy and mistletoe as a plant of Christmas. It was strewn on floors so that its delightful scent would perfume a dwelling as Christmas revelers walked on it. The herb's fragrance was believed to repel evil spirits as well as bless homes during the Yuletide. Anyone who breathed rosemary at Christmas would know much happiness throughout the year. Its magical qualities were such that women had small boxes made from the wood of a mature rosemary shrub in the hope that the scent of these boxes would keep them young.

Rosemary had been named in honor of Mary, Jesus' mother, and the legends surrounding it reflected that. It had supposedly acquired

Rosemary supposedly acquired its delightful fragrance when Mary placed Jesus' swaddling clothes over a rosemary bush that was growing near the Bethlehem stable.

its scent when Mary placed Jesus' swaddling clothes over a rosemary bush that was growing near the Bethlehem stable. Another legend maintained that the herb's flowers originally had been white but forever became blue when Mary cast one of her blue cloaks on a rosemary bush during the flight into Egypt. Bancke's *Herbal* (1525), the earliest of all English herbals, claimed that a rosemary bush, if left uncut for thirty-three years, would reach the precise height Jesus attained when he walked upon Earth.

The Puritans officially outlawed the observance of Christmas when they came to power in seventeenth-century England, and rosemary fell on hard times. It had been named in honor of Mary, whom Roman Catholics worshiped, and was associated with the revelry and excesses of the Christmas season—a double whammy in Puritan eyes. Puritans enacted severe punishments for anyone who closed their business in observance of Christmas or attended a special religious service to commemorate Jesus' birth.

But the English grew sick of such fanaticism. The Puritan regime collapsed, Charles II returned from exile in 1660 to assume the

throne and Christmas was restored. Rosemary again assumed its place in the celebration of a merry English Christmas.

For reasons that remain obscure, rosemary fell out of favor as a Christmas decoration during the Victorian era. I learned of its former importance while doing some research on Yuletide customs. Later, I was fortunate enough to meet a few people who were also aware of rosemary's heritage and wanted to keep this old Christmas custom alive. I began cultivating the herb and always tried to have a potted rosemary in my home at Christmas. I emphasize "potted" because rosemary is classified as a "tender perennial," which means that it can survive outdoors only if winters are mild. A prolonged period of freezing temperatures is a sure death sentence.

The plant from our neighbors is doing quite nicely this winter in our sunny kitchen. Our holiday guests are always amazed when I tell them about rosemary's place in Christmases of long ago. Some of our guests say they intend to buy rosemary for their homes. With any luck at all, rosemary just might again become an integral part of the celebration of Christmas.

Purchasing a poinsettia, on the other hand, has long been a holiday tradition for many southern Illinoisans. That lovely plant with its showy red leaves graces countless homes, businesses and churches during the Christmas season. The poinsettia as the premier Yuletide plant dates to the seventeenth century, when Franciscan priests in southern Mexico added them to the celebration of Christmas. Known as *Flor de la Nochebuena* (Flower of the Holy Night) and *Flor de Navidad* (Flower of Christmas) south of the border, the plant acquired its English name from Dr. Joel R. Poinsett, a South Carolina botanist who served as our nation's first ambassador to Mexico from 1824 to 1929. Poinsett sent some specimens to his home, where they were cultivated and shared with other botanists. Improved varieties of the plant in the twentieth century helped to popularize the poinsettia as a beautiful addition to holiday decorations.

The name *Flor de la Nochebuena* hints at a legend that purportedly explains the origin of this plant as well as its association with Christmas. I can't recall when and from whom I first heard the story. I *can* recall, however, that knowing this delightful story never failed

The poinsettia, known as *Flor de la Nochebuena* and *Flor de Navidad* in its native Mexico, is the subject of several holiday legends.

to enhance my appreciation for the poinsettia my parents purchased for our home each Christmas.

It was the custom long ago among the villagers in a certain Mexican town to journey to church on Christmas Eve and lay a gift of money next to the manger holding a statue of the infant Jesus. The money was used to buy provisions for the poor people of the village, as well as to support the church. A certain little boy came from a family so impoverished that it typically received some of these provisions. The lad wished with all his heart that he, too, could leave some money by the manger. As he stood outside the church on Christmas Eve, tears began to run down his face and fall to the ground.

Then, a miracle occurred! Each time one of his tears fell on the soil, a beautiful plant sprang up. Some of its leaves were green, but others were fiery red—completely unlike any known plant. The boy realized that his prayers and longing had reached God, and he had been provided with a special gift to place next to the manger. He gathered up some of the mysterious plants and took them inside the

church. The priest and the villagers were amazed at this miracle. Since this plant with the beautiful red leaves had sprung into existence on Christmas Eve, it became known as *Flor de la Nochebuena*.

Another version of the poinsettia legend has a poor Mexican girl named Pepita who is sad because she has no gift to place before the Nativity scene in the village church on Christmas Eve. Her cousin Pedro assured Pepita that the infant Jesus would find any gift acceptable, if it truly came from her heart. The girl pulled up some weeds and placed them before the Nativity scene. The weeds miraculously turned into flowers with beautiful red leaves.

For most of us, the poinsettia is the traditional flower of Christmas. But for a historic old church in the French Colonial District of southern Illinois, that distinction belongs to the lily. The Immaculate Conception Mission was founded near present-day Utica, Illinois, in 1675 by the renowned Jesuit explorer Jacques Marquette, who died later that same year. The Jesuits relocated the mission to Kaskaskia in 1703. The first stone building to serve as the Immaculate Conception Church was built in 1714.

A procession of women commemorates the miracle of the lilies each year at the Immaculate Conception Church in Kaskaskia.

Located on the Mississippi River, Kaskaskia—now a tiny village—became an important trading center. Kaskaskia and Cahokia, which was founded in 1699, were the earliest pioneer settlements in what would later become the Prairie State. When Illinois was admitted to the Union in 1818, Kaskaskia served as the first state capital.

Immaculate Conception Church was rebuilt several times as Kaskaskia grew. King Louis XV of France gave the church a 650-pound bell, which was cast in 1741, arrived in New Orleans in 1743 and made a laborious trip up the Mississippi to Kaskaskia. It became known as the Liberty Bell of the West after it was rung to celebrate the capture of Kaskaskia on July 4, 1778, by George Rogers Clark for the fledgling United States. The bell is on display today in a special building adjacent to the church.

Not surprisingly, the feast of the Immaculate Conception, observed on December 8 in the liturgical calendar of the Catholic Church, always has been a day of celebration at the Immaculate Conception Church. One long-ago December 8, according to legend, a sad Native American woman made her way to the church.

John White and Father J. David Corrigan at the Immaculate Conception Church during the lily procession.

# Christmas

The author's bookstore features a Christmas cactus that blooms every Yuletide.

Members of the congregation traditionally brought a gift to the church in honor of Mary, but this woman came from a poor family. She would arrive empty-handed. Just before entering the church, her downcast eyes noticed lilies blooming through the snow and ice. She gathered up an armful and brought them into the church as her gift. The congregation and priest were amazed.

Honoring the Legend of the Lilies, a procession of women commemorates this miracle every year at Immaculate Conception Church by carrying lilies. They place the lilies in a vase before the statue of Mary while singing a hymn in a Native American language. The lilies remain in the church through December as part of its celebration of Christmas.

# Christmas at Camp River Dubois

Accounts of Christmas celebrations in southern Illinois before statehood was granted in 1818 are understandably rare. The earliest pioneers were too concerned with matters such as obtaining food and surviving the region's grueling winters to record holiday celebrations—or even to observe festivals such as Christmas, for that matter. Still, we are fortunate to have a brief description of a southern Illinois Christmas in 1803. The account was written by none other than William Clark, who, along with Meriwether Lewis, led the men of the Corps of Discovery in their exploration of the American West.

When Thomas Jefferson assumed the presidency in 1801, he appointed Lewis as his private secretary. A lieutenant in the U.S. Army and an accomplished woodsman, Lewis possessed a solid knowledge of America's western frontier—the Indiana Territory, which included present-day Illinois.

President Jefferson instructed Lewis to study botany, zoology, geography, ethnology and celestial navigation. Our nation's third president then secretly appealed to Congress in 1802 to fund an expedition to the Pacific Ocean that Lewis would lead. The following year, Lewis began recruiting volunteers for this expedition, which was designated the Corps of Discovery.

Jefferson hoped that Lewis would find "the Northwest Passage," a waterway that stretched to the Pacific Ocean. He also wanted to

learn more about the great expanse of land known as the Louisiana Purchase, which the United States acquired from France in 1803, and to establish trade with the tribes of Native Americans who inhabited it. Lewis, who was promoted to the rank of captain, asked William Clark, a former soldier with whom he had served, to co-command the expedition with him.

Secretary of War Henry Dearborn authorized Lewis to call on the commanding officers of Fort Massac and Fort Kaskaskia, both located in the future state of Illinois, to recruit soldiers for volunteer service in the expedition. Lewis left Pittsburgh by keelboat in August 1803 and was joined by Clark in Clarksville, Indiana Territory. They journeyed down the Ohio River to Fort Massac, which was located at present-day Metropolis, Illinois, where they acquired three volunteers for the Corps of Discovery. At Fort Kaskaskia, located on the Mississippi River, Lewis and Clark obtained eleven more volunteers. Illinois enjoyed the distinction of contributing more men to the Corps of Discovery than any other state or territory.

The corps would winter in southern Illinois before beginning the epic journey west. Lewis selected a site located on four hundred acres of land owned by Nicholas Jarrot of Cahokia. The camp was established at the mouth of a small river called Dubois—in English, the Wood River. At that time, the mouth of the Dubois was located opposite the mouth of the Missouri River. Both rivers flow into the mighty Mississippi. This site became the Corps of Discovery's Camp River Dubois. Patrick Gass, a Fort Kaskaskia recruit with carpentry skills, constructed the log buildings of the encampment.

While Lewis spent time in Cahokia and St. Louis gathering maps, as well as all available information about the territory that the Corps of Discovery would enter in the spring of 1804, Clark remained at Camp River Dubois to prepare for the journey. Clark organized the volunteers into groups with specific duties such as blacksmithing, preparing the keelboats and gathering supplies for the long journey into the West. Firewood had to be hauled into the camp on sleds built by Gass. Sergeant John Ordway, yet another Kaskaskia volunteer, took charge of the camp during the absence of both Lewis and Clark.

The reconstructed Camp River Dubois, where Lewis and Clark spent Christmas 1803, is located at the Lewis and Clark Historic Site in Hartford.

A hunting party left Camp River Dubois daily to keep the men supplied with fresh meat. The volunteers enjoyed a steady diet of deer, turkey, badger, wildcat, wild hog and other game. This high-protein diet was supplemented by area residents, who brought butter and vegetables to Camp River Dubois as gifts or items for barter.

Lewis and Clark knew that the journey westward was fraught with danger. The volunteers at Camp River Dubois were drilled daily in rifle marksmanship and sometimes held shooting competitions with neighboring residents. Clark was awakened before daybreak on December 25, 1803, by the sharp report of rifle fire. Camp River Dubois was not under attack by a hostile tribe, however. Those rambunctious young men were firing into the air to celebrate the Nativity.

Military discipline was strictly observed at Camp River Dubois. Drunkenness, fighting and leaving the camp without permission brought reprimand and punishment. Still, Clark knew when to cut his men some slack, and Christmas Day was one of those times. He wrote in his journal that he gave all the men a little tafia, which is a rum made in the West Indies from sugar cane, and permitted three

Log cabins near the fort at Camp River Dubois.

cannons to be fired when the camp's flag was raised. A hunting party left Camp River Dubois to provide Christmas dinner, while the other men danced and enjoyed themselves until 9:00 p.m., when, according to Clark, the "frolick [*sic*] ended."

The Corps of Discovery departed Camp River Dubois on May 14, 1804. The men celebrated Christmas during their journey, although the abundant game necessary for a genuine holiday feast was sometimes hard to come by. Christmas Day 1805 found Lewis and Clark wintering at Fort Clatsop in the Pacific Northwest. Clark wrote that dinner consisted of "pore [*sic*] elk" that was so spoiled it was eaten only out of dire necessity. This elk meat was supplemented by spoiled pounded fish and a few roots." The men surely recalled their Christmas dinner at Camp River Dubois with great fondness.

# Christmas and the Peculiar Institution

I llinois is popularly considered a free state in which slavery had no place. Mississippi River cities such as Quincy, Alton and Chester were important depots on the Underground Railroad, where escaped slaves could find food and shelter before continuing their journey to northern points. Illinois stood by the Union during the Civil War and provided thousands of troops for the Federal armies.

While the Northwest Ordinance of 1787 had banned the introduction of slavery into the future state of Illinois, it allowed the old French families to keep their slaves—and even the descendants of these slaves. Slaveholders who immigrated to Illinois from other states, such as future Illinois governor Ninian Edwards, were permitted to keep their slaves. As many as 2,000 slaves, who were loaned out by their Kentucky masters, labored at saltworks near the Saline River in southern Illinois. When Edward Coles, another future governor, arrived in Illinois in 1819, he settled in Madison County, where the author of this book makes his home. The Madison County of that day had 110 black residents: 33 free and 77 held as slaves.

The casual observer might have concluded that the period between Christmas and New Year's Day was an uncharacteristically joyous time for slaves. Slaveholders traditionally allowed the slaves a holiday during this period by releasing them from their usual labors. Some slaves chose to hunt rabbits, raccoons and other small game,

The Dunphy Building at 16 East Broadway served as a stop on the Underground Railroad.

while others immersed themselves in handicrafts such as the making of baskets, mats and corn brooms. According to the renowned ex-slave and abolitionist Frederick Douglass in his autobiography, however, most slaves chose to spend the holidays playing rough games, dancing and drinking—much to the delight of their masters. "A slave who would work during the holidays," Douglass noted, "was thought, by his master, undeserving of holidays. Such a one had rejected the favor of his master."

Douglass saw through this holiday sham. Slaveholders allowed their captives this once-a-year holiday from the horrors of their daily existence for reasons that had nothing to do with benevolence:

*Before the holidays, these are pleasures in prospect. After the holidays, they become pleasures of memory, and they serve to keep out thoughts and wishes of a more dangerous character. Were slave-holders at once to abandon the practice of allowing their slaves these liberties, periodically, and to keep them, the year*

*round, closely confined to the narrow circle of their homes, I doubt not that the south would blaze with insurrections. These holidays are conductors or safety valves to carry off the explosive elements inseparable from the human mind when reduced to the conditions of slavery.*

Slaves in southern Illinois, who were afforded a bit of leisure from Christmas to New Year's, hardly experienced the warmth and joy that white residents knew so well. The holidays, supposedly a time of happiness for these men, women and children held in bondage, could also be a time of horror. A photograph on display at the Abraham Lincoln Library and Museum in Springfield makes this quite evident. A slave named Gordon has removed his shirt to display the scars left by a flogging. The caption notes that Gordon was beaten by his master on Christmas Day 1862. He then ran away to join the Union army.

While the caption does not identify the state in which Gordon resided, any slave was vulnerable to such an outrage—including those held in southern Illinois. His story is every slave's story. The fact that Gordon's flogging occurred on Christmas Day underscores the horror of the peculiar institution for those held in its grasp.

I have one very personal account of an African American Christmas in old southern Illinois. Aunt Dot, Uncle Joe's wife, grew up in the historic Hurlbut-Messenger house, which was located on Washington Avenue in Upper Alton. The site of Shurtleff College and Western Military Academy, Upper Alton was a separate city from Alton until it was annexed in 1911.

Built for Thaddeus Hurlbut, an ally of Elijah Lovejoy who was with the renowned abolitionist newspaper editor on the night he was murdered in 1837, it was a station on the Underground Railroad. My mother told me about seeing, as a child, the cavernous basement where slaves were hidden before being spirited off to their next destination on the path to freedom. Another relative told me about a long tunnel that extended from this basement to—who knows where? The house was later acquired by Benjamin Franklin Messenger, a Union veteran of the Civil War, who had four children with his wife, Helen Boardman Messenger: Benjamin, Charlotte,

The historic Hurlbut-Messenger house, where the author's great-aunt grew up, was another Alton stop on the Underground Railroad. This photo was taken in the 1920s.

John and Dora. Charlotte Messenger married John Horton, and the couple had one child: Dorothy (Dot) Horton, who married Joseph (Joe) Dromgoole.

While Uncle Joe grew up poor in Alton's Hunterstown neighborhood, Aunt Dot enjoyed a rather privileged life in the Hurlbut-Messenger home. Servants were just a rumor in Hunterstown—unless one was fortunate enough to work as one. The Hurlbut-Messenger house, on the other hand, had a live-in servant who had once been a slave.

"Auntie" Sims, as she was called, and her husband had been slaves at the Donaldson plantation in Tennessee when they had been freed during the Civil War. They made their way to Illinois and settled on a farm "somewhere north of Madison County"—precisely *where*

north of Madison County remains unknown. When her husband died, Auntie Sims made her way to Upper Alton and arrived at the Hurlbut-Messenger house with her few belongings. She supposedly announced upon arriving that "she was ready to take over" and did precisely that, assuming responsibility for managing the household. Benjamin Franklin Messenger had died in 1892, leaving Helen to raise their children herself. Finances had compelled her to sell the home to Amos Benbow, a prominent Madison County politician who would later found the legendary Benbow City, a rollicking town of saloons and brothels near present-day Wood River. Benbow allowed Mrs. Messenger to remain at the family home as his housekeeper, and ownership of the house reverted to her in 1922 when Benbow died. Auntie Sims remained in the house as a servant during Benbow's ownership.

The former slave shopped for the household. Upper Alton residents saw her walking from the Hurlbut-Messenger house to Upper Alton's business district while singing hymns and lullabies. She was permitted to hang a stocking at Christmas alongside the stockings of the Messengers. On Christmas Day, according to a manuscript in the author's possession, "Her chief delight was looking for a bottle of her favorite spirit at the bottom of her stocking, which she immediately took to her room and she was not seen until the following day."

Auntie Sims's years as a slave evidently had left her incapable of celebrating Christmas without alcohol.

# The Magic of
# Old Christmas

The families of English, Scottish and Scots-Irish descent brought their own Christmas lore and customs to southern Illinois. Kaskaskia's Immaculate Conception Church has its Christmas lilies. Many years ago, I heard a story from a customer who stopped by my bookshop about another flower that ordinarily one doesn't associate with Christmas—a rose. This tale, however, occurred not on December 8 or even December 25. It happened on January 6, a date that many families in southern Illinois and much of rural America knew as Old Christmas.

In a sense, Christmas came twice in this earlier America. December 25 was often referred to as "New Christmas" to distinguish it from "Old Christmas," which fell on January 6. Although in 1752 Great Britain adopted the revised Gregorian calendar, which established December 25 as the anniversary of Jesus' birth, some British traditionalists—including many colonial Americans—continued to observe January 6 as Christmas, the date on which it fell according to the old Julian calendar that Britain had abandoned.

Residents of isolated rural communities, such as those that once existed in southern Illinois, often ignored December 25 and continued to celebrate Old Christmas until well into the twentieth century. For some southern Illinoisans, Old Christmas was a time for retelling many beautiful legends and folk beliefs. Bees were said to hum the $100^{th}$ Psalm in their hives at the stroke of midnight.

It was also at midnight that water in wells and streams magically turned into wine, while all fruit trees miraculously blossomed and bore fruit that vanished just before daybreak's first light. The very dawn on Old Christmas morning was always especially beautiful and said to be marked by *two* sunrises, a phenomenon that some old-timers even claimed to have witnessed!

Families often made a ritual of opening a window on Old Christmas morning to allow all the year's bad luck to escape, while others flatly refused to throw out ashes from the stove or fireplace, since there was the danger that one might inadvertently "throw them into the Savior's face."

Ghosts supposedly walked the earth on this day. "Old Christmas," a poem by Roy Helton, expresses this belief with a beauty and poignance I haven't found anywhere else. Before sunup on Old Christmas morning, a young woman named Lomey Carter stops by the cabin of the man who killed her husband. Taulbe Barton, the murderer, isn't home, but Sally Ann, his wife, invites Lomey to enter and rest for a while. When asked where she had been so early in the morning, Lomey replies that she visited the graveyard near the salt-lick meadow, where Barton had killed her man. There, she had seen her husband's ghost. The specter's head was still bleeding where Barton's bullet had passed completely through it.

Lomey tells Sally Ann that the ghost kissed her and said that Jesus had forgiven Barton for this murder. He then whispered something to Lomey—she doesn't tell Sally Ann what it is—before vanishing. When Sally Ann again remarks that Taulbe isn't home, Lomey reveals that she shot him to death with her late husband's rifle in the same meadow where he had killed her man. Sally Ann says that she heard *two* shots. That second gunshot, Lomey explains, came from the rifle of Taulbe, who managed to kill her before he died. Sally Ann had been talking to a ghost on this Old Christmas morning.

One of the most widely held Old Christmas beliefs was the notion that the weather on that day and the eleven succeeding days was indicative of the weather for each of the twelve months of the new year. For example, if January 6 was marked by snow, then there would be a great deal of snowfall throughout the month of January, while an unseasonably warm January 12 was a harbinger of a hot, dry July.

I rather doubt, however, if even the staunchest proponents of this meteorological theory really believed that a blizzard on January 13 meant that there would be snow in the month of August. A more reasonable interpretation would have been that snowfall on January 13 heralded an August during which there would be considerable precipitation.

One of the most pervasive legends of southern Illinois and much of rural America maintained that all perennial flowers roused themselves from dormancy at midnight on Old Christmas Eve and bloomed in honor of the Savior's birth. The daintiest, most beautiful flowers of spring and summer could be found blossoming through even the harshest snow and ice, if only one cared to look. The customer who stopped by my bookshop that day had been told such a story by his mother.

It seems that this man's mother, as a little girl in southern Illinois, had heard about the legend of all the sleeping perennial flowers pushing up new life through the snow and frozen ground on Old Christmas Eve. She took the story with a generous grain of salt, since she had never seen any evidence of it. That is, until one very special Christmas. She was awakened by her father late on Old Christmas Eve. She recalled that his eyes were shining, his mouth was "grinning from ear to ear" and his hand was holding a beautiful red rose.

The rose, its bud still tightly furled, was lightly dusted with snow. Yes, her father had told her, the rose was from their yard! The old rosebush had bloomed in celebration of Jesus' birth, just as the legend claimed, and this lovely rose was the living proof!

It was so beautiful, his mother said, that she didn't know whether to laugh or cry. Her father then placed the rose in an old Mason jar filled with water that he had brought with him, wished her a Merry Christmas, kissed her and told her to go back to sleep.

The rose, resting in that chipped Mason jar, was the first thing she saw when she awoke on Christmas morning. No present she received that Christmas—or any other Christmas, either as a child or an adult—rivaled that single rose that had bloomed on the family rosebush at midnight, just as she had always been told.

Of course, his mother said, a couple of years later she figured out what had really happened. Her father had obviously purchased

A legend claims that all dormant perennials, such as roses, rouse themselves from dormancy on Old Christmas Eve and bloom in honor of Jesus' birth.

the rose in town, brought it home but kept it hidden from her and then dipped it in the snow before taking it into her room that night. But her surprise upon being awakened that Old Christmas Eve, the sheer joy she felt from finally knowing that the legend of the blooming flowers *must* be true, was a memory his mother treasured all her life, the son told me.

I came to treasure his mother's story after hearing it that day in my bookshop. Now you can treasure it, too.

Yet another Old Christmas legend claimed that precisely at midnight all farm animals kneeled in their stalls to adore the newborn Jesus and praised him with human voices. Animals had supposedly been granted this once-a-year privilege since they had been the only

witnesses to the Savior's birth in the Bethlehem stable and were said to have breathed on the Holy Infant to keep him warm on that chilly night so many centuries ago. In fact, Old Christmas Eve was sometimes referred to as "the night the animals talk."

The only other Old Christmas tale I've heard that even begins to rival the rose story came from a southern Illinoisan I met at my bookshop who shared a story she had been told by her grandfather. As a boy, the grandfather crept out of the house while everyone in the family was asleep and made his way to the barn. He was determined to learn if the tales he had been told of animals kneeling down and speaking in human voices on Old Christmas Eve were true, and this was the only way to find out.

But the lad's curiosity was not sufficient to thwart his sleepiness, and he soon dozed off while curled up on a pile of hay. Suddenly, he was awakened by the sound of someone calling his name! Leaping to his feet, he initially thought he had been discovered by his parents. But, to his profound amazement, he saw that he was alone in the barn—except for the animals. As he hurriedly returned to the house, he surmised from the position of the moon that it was just about midnight.

When I asked my customer who had called out her grandfather's name in the barn on that Old Christmas Eve so long ago, she said that she would give me the same response her grandfather had given her when she had asked the same question. The old man had just slyly winked at her and replied, "Who do *you* think?"

As Old Christmas faded from memory, some of its legends and traditions were transferred to December 25. *Springhouse* magazine, a southern Illinois literary treasure that has played a vital role in preserving the folklore of Egypt, recently carried a firsthand account of some Christmas Eve magic that involves farm animals. The creatures in this story, however, are less talented or perhaps just shyer than the animals that temporarily gain the power of speech. But let the author tell it *his* way.

Don Floyd was born and grew up in a family of sharecroppers "in the southern tip of Illinois down in the Ozark Hills." While he has many pleasant memories of his childhood, he wrote, "my very favorite is Christmas Eve with my Mother, my Father, and two sisters."

Floyd and his sisters would be asleep in their beds when their parents awakened them. After dressing in their warmest clothes, they walked to the kitchen to meet their parents. Their father would light a coal oil lantern and lead his family from the house to the barn. "Daddy would open the door to the tack room," Floyd recalled, where harnesses for the horses and mules were kept. When everyone had entered the tack room, "Daddy would blow out the coal oil lantern." While maintaining silence, the family then joined hands to make a circle. What then happened should be told by Floyd in his own words.

> *At the stroke of midnight, exactly midnight, the cattle would commence the most soothing mooing, humming-like sound. It was like a lullaby. Soon all the other animals would join in. The horses, the mules, the sheep and the goats, the pigs and the chickens would all join in to produce this unique sound.*
>
> *It was difficult for the listeners to resist raising their hands to the heavens and shouting, "Praise the Lord!" The animals were singing, in their own way, a lullaby to the baby Jesus who was born this very night, all those many years ago, in a little town called Bethlehem. This beautiful lullaby would go on for several minutes but, when it ended, it would be so silent in that old barn that all you could hear would be the creaking of the timbers.*
>
> *Daddy would relight the coal oil lantern then. Momma would say a prayer. Daddy would light our way down the narrow path while we sang Christmas carols.*

Upon reaching their house, which was warmed by a wood-burning stove, the parents would drink coffee while the children enjoyed hot chocolate. "Daddy would tell us how the animals would always, at midnight, on Christmas Eve, talk and sing this lullaby to the baby Jesus," Floyd concluded.

If traditions such as these are still observed in the southern Illinois of today—or anywhere in rural America, for that matter—I have yet to learn about it. But I like to think that somewhere at midnight on December 25 or January 6, flowers are still said to bloom in the snow and children stay up to see whether animals speak in human voices.

# New Year's

# Getting Off On the Right Foot

For most Americans, New Year's Day is a time for watching football on TV, making resolutions that are about as sincere as a politician's promises and recovering from last night's revelry. But in the southern Illinois of years past, New Year's was a very different time, a time of fascinating customs and folk beliefs that lent the day a warmth and richness quite lacking in its modern counterpart.

Many observances dealt with which foods should be eaten precisely at midnight on New Year's Eve to ensure good luck throughout the year. Black-eyed peas seem to have been the most popular menu item among southern Illinoisans in those days, with beans running a close second. Ham and beans were often served for dinner on New Year's Day at the Dunphy household. I recall hearing of a German-descended family that chowed down at the stroke of midnight on—of all things—pickled herring!

My wife and I always host an open house on New Year's Day. We have much of the food catered but make a point of cooking a huge pot of black-eyed peas that we simmer with a ham bone so large one might think it came from a dinosaur. Our guests enjoy the catered food, but the black-eyed peas consistently garner the warmest compliments. Most of our friends are familiar with the notion of eating black-eyed peas on New Year's Day for good luck and compliment us on keeping the old tradition alive.

One gentleman, while enjoying his second bowl, told me that ours were some of the best "Texas caviar" he had ever tasted.

"The best *what?*" I asked, my ear for folklore quickly shifting into high gear.

"Texas caviar," he repeated. "That's what I always call black-eyed peas." I have since learned that other aficionados of this delicacy refer to it as Ozark caviar or hillbilly caviar. The name may vary according to region, but the tradition of enjoying a bowl of black-eyed peas on New Year's Day remains popular, particularly in the Midwest and South.

Some southern Illinoisans made a habit of opening a window at midnight to allow all the old year's bad luck to escape from their homes and the new year's good fortune to enter. My family's ritual was a bit different. We would open the front door at midnight for a few moments to "let in the new," as my mother typically put it, while listening to the bells of nearby churches peal in celebration of another year.

We also heard fireworks set off by neighborhood children, as well as a few gunshots. They probably were unaware that fireworks and gunshots at midnight on New Year's Eve were rooted in an old custom of making noise to drive away evil spirits. For the kids, it was a chance to use up fireworks left over from July 4, while a few gun owners welcomed any excuse to discharge their beloved weapons. I still smile at the memory of one gentleman whose ill-aimed shotgun blast struck a pole-mounted power transformer and knocked out his neighborhood's electricity.

I also recall accounts of residents who allegedly slept with horseshoes under their pillows on New Year's Eve to ensure good luck. I've tried in vain for years to locate an adherent of the custom to inquire whether this practice and a good night's sleep were mutually exclusive.

A particularly prevalent notion in southern Illinois and the Missouri and Arkansas country was that one's behavior on January 1 was indicative of one's behavior for the entire year. As Vance Randolph noted, drunkards usually made a superhuman effort to remain sober on New Year's Day. He recalled seeing men anxiously sitting with watches in one hand and whiskey jugs in the other as

they waited for midnight on January 2 before taking their first drink of the new year.

New Year's Eve, both past and present, meant an excuse for inebriation, but not in the Dunphy or Dromgoole households. Although my father carried on a lifelong love affair with Anheuser-Busch products, he took no interest in December 31 as a time of celebration. He and my mother rarely went out together and, much like other working-class couples of their generation, had staked out separate social lives. Dad's revolved around Alton's Rock Springs Golf Course and his favorite tavern of the moment, while Mom's centered on her parish, St. Mary's Catholic Church. The very idea of my parents partying hardy on New Year's Eve seemed ridiculous.

Aunt Dot and Uncle Joe might have stepped out in their youth, but the gray-haired couple I recall spent a quiet New Year's Eve at home. The next day, however, they often hosted an informal open house. For them, New Year's was a time to strengthen one's bonds with family and friends. This is the family tradition that my wife and I carry on each New Year's Day with our open house.

Perhaps the most intriguing facet of a New Year's in southern Illinois was its observance of "first-footing." Known in varying forms from Ireland to China, first-footing refers to the belief that the first person to enter a dwelling on the first day of the year is capable of bestowing an abundance of either good or bad luck on that dwelling's family for the entire year.

The Dunphys practiced what can be called an extremely modest form of first-footing. Faye, my mother's cousin who was almost like a sister to her, lived with her husband in a small apartment across the street from us. She was, simply by proximity, usually the first person to visit us on New Year's Day. We never assumed that her visit would bring us good luck; indeed, she and her husband had endured more than their share of economic hardship and were compelled to live frugally. Still, we felt blessed that the first person to cross our threshold was a beloved relative, and her visit served to remind us of the importance of family.

Old-time southern Illinoisans, however, took first-footing much more seriously. The "first-footer" of choice for them was a man, preferably a relative or friend of the family. There was a widely held

prejudice that a female should not be the first person to enter because it was thought to spell an entire year of bad luck for the hapless family.

Because a first-footer could not be someone who lived in that particular house—no, a family member could not just step outside and then walk back in—many families had long-standing arrangements with neighboring relatives or friends to have a male "call on them" the very first thing on New Year's Day.

I heard a story about a southern Illinoisan first-footing gone awry. It seems that the head of one household left his home on New Year's Day to perform the first-footing observance for a neighboring family, just as the patriarch of that family had done for this family for years. While he was gone, a young boy stopped by the house and claimed to be a visiting cousin of that other family. The lad informed them that his uncle, the head of that household, was ill, as were his two sons, so the duty of first-footing had fallen to him, as the only healthy male in the house.

While it was quite unusual for one so young to be a first footer, the family recognized that circumstances warranted a change in tradition and welcomed the stranger into their home. Although the boy was personally unknown to them, everyone remarked on his strong physical resemblance to his hosting relatives.

A short time after the boy left, the head of the household returned from his first-footing duty at the neighbors' home. His family thought that he acted rather strangely and asked if anything was wrong. Uncharacteristically grumpy, he mumbled "no" and asked how long until dinner, as lunch was usually called in the southern Illinois of years past.

My informant told me that it was many years later when the man confessed to his family the deceit he had played on them that New Year's Day, a deceit born of the necessity to conform to a time-honored tradition. When he arrived at his neighbors' house that morning, he had indeed found the patriarch and both his sons ill and unable to make the journey to his place. But there had been no visiting male cousin. In fact, the only healthy people in the house were the patriarch's wife and his two daughters.

Recognizing what had to be done, he had his neighbor's wife clip the younger girl's hair, dress her in the old clothes of one of her

brothers and send her to his place as a male first-footer. My informant concluded her account by noting that the man's confession included the admission that he had never held first-footing in especially high regard after that New Year's Day because, even with a girl as a first-footer, his family had not experienced any devastating bad luck during that year.

Stunned by this revelation, the family decided to discontinue the first-footing tradition and let chance determine who would be the first person to cross their threshold on New Year's Day.

# Watch Night

Southern Illinois contains a number of historic African American settlements, some still in existence and others vanished. Saline County's Pond Settlement, also known as Lakeview, was founded by free African American settlers who journeyed to the area from North Carolina shortly after the War of 1812. Residents of Pond Settlement aided runaway slaves as they fled north to freedom. The town of Grayson, also located in Saline County, was established by Neal Elliott, an ex-slave from Kentucky who purchased his freedom and, later, the freedom of his wife and mother.

A community poignantly named Eden existed in Randolph County. Eden had been settled by free African Americans before the Civil War. Its residents, in turn, assisted other members of their race to win freedom as they traveled north along the Underground Railroad. Miller Grove, also founded by free African Americans, was located in what is now the Shawnee National Forest country of Pope County. The settlement was a farming community whose residents built a church and a school. Its cemetery holds over one hundred graves.

Brooklyn, located in St. Clair County, was founded in the 1820s by a band of freed and fugitive slaves who made the settlement a vital link on the Underground Railroad. The first social institution organized in this pioneer settlement was an African Methodist Episcopal (AME) Church. Oral tradition attributes this church's founding in 1825 to the effort of the Reverend William Paul Quinn,

a circuit-riding AME missionary. The small congregation originally gathered in the cabin of the Baltimore family. As the number of worshipers increased, Brooklyn residents built a log church, which may well have been the first AME church west of the Allegheny Mountains. This historic church, now known as Quinn Chapel, still exists in Brooklyn. Tunnels from its Underground Railroad period are beneath Quinn Chapel.

Brooklyn's residents fearlessly aided African Americans fleeing the shackles of slavery. Priscilla Baltimore played a crucial role in facilitating this flight to freedom.

Born of a slave mother who was impregnated by her white owner—the father-in-law of the former governor of Missouri—Baltimore was already a Methodist convert when she was purchased by a Methodist missionary for $1,100. Deeply committed to her faith, Baltimore was permitted to preach to area slaves. Somehow, she earned the money to purchase her freedom from the missionary and led a group of African Americans to the site that became the town of Brooklyn.

But Baltimore was not content merely with securing her own freedom and leading a modern-day exodus to the free state of Illinois. She willingly risked capture and re-enslavement by ferrying Quinn across the Mississippi so that he could preach the gospel to St. Louis African Americans. Quinn's congregation met in members' homes and eventually evolved into St. Paul's AME Church, which enjoys the distinction of being the oldest African American church in St. Louis. When Quinn returned to Illinois, he often brought fugitive slaves with him.

Quinn's resourcefulness became the stuff of legends. When apprehended by slave catchers outside of St. Louis and brought to court, he purportedly asserted that he was a native of India and a British subject. American laws did not apply to him, he concluded in his address to the court. Incredibly, the authorities believed him! He was released and ordered to leave Missouri.

The Rocky Fork settlement in Madison County was another early African American community in southern Illinois. Unlike Brooklyn, however, it never became a town. While Brooklyn was founded by freed and fugitive slaves, Rocky Fork was composed entirely of fugitive slaves who had crossed the Mississippi River and found

refuge at the present-day location of a Boy Scout camp, just off Illinois Route 3 in Godfrey.

Don Alonzo Spaulding, a Vermont native who loathed slavery, owned the land occupied by the Rocky Fork settlement and provided employment for its residents at his sawmill. Harry Spaulding, his brother, also resided in the area. Harry served as justice of the peace, and his presence provided a measure of security for the fledgling community. Under the Spauldings' protection, Rocky Fork became a destination for runaway slaves who followed Piasa Creek and then Rocky Fork Creek to this safe haven. Rags tied to trees also assisted slaves in their quest to find Rocky Fork.

Two old hollow trees were particularly important. One of these trees, called the Mail Tree or Message Tree, was located near Illinois Route 3/Old Route 100 and held messages for fugitive slaves. The other tree, known as the Slave Tree, was located near Rocky Fork Creek and contained information about Underground Railroad stations.

Local historians also mention the Hanging Tree, which was located in the Rocky Fork area. Slave catchers from Missouri caught a runaway slave and, rather than returning him, hanged the slave from the tree. Perhaps the slave catchers left his body dangling to warn the other fugitives living in the area that they would suffer the same fate if captured. The tree was struck by lightning many years ago and then cut down.

Permanent residents of Rocky Fork served as guides who brought over slaves from Missouri. These escapees could remain at Rocky Fork or, more likely, continue their journey north. While no written records exist, researchers estimate that hundreds of escaped slaves passed through Rocky Fork. Historians of the Underground Railroad state that the area is second only to Cincinnati in its significance.

The secluded location of the Rocky Fork settlement worked to ensure that many area residents were unaware of its existence. It seemed, to those who chanced upon it, nothing more than a community of free blacks who lived in widely dispersed cabins and worked at Spaulding's sawmill. Ironically, this subterfuge worked so well that even today many area residents believe that Rocky Fork was founded by free blacks before the Civil War or by blacks who had been freed during the Civil War.

# New Year's

New Bethel AME
Church in Godfrey
was founded by
fugitive slaves who
lived at the Rocky
Fork settlement.

Rocky Fork had its own cemetery, as well as a campground where religious services were performed. These worshipers became the nucleus of an African Methodist Episcopal Church congregation at the Rocky Fork Settlement. The congregation erected its first church building in 1863 to mark the Emancipation Proclamation. Arasmus Green, a veteran of the Union army's Colored Infantry Volunteers, served as the church's first minister. The original church building was replaced by a new one in 1926.

The New Bethel AME Church at Rocky Fork still exists, proudly bearing witness to the faith of those long-ago escaped slaves. The church, located on Rocky Fork Road just off Illinois Route 3 in Godfrey, suffered vandalism in the 1970s and was destroyed by arson in 1988. Members of the River Bend community were outraged and rallied to rebuild the church.

The Brooklyn and Rocky Fork churches belong to the African Methodist Episcopal denomination, which has a tradition of holding a "Watch Night" service on New Year's Eve. There has been a great deal of misinformation concerning the origin and purpose of Watch Night in the African American religious experience. Some insist that Watch Night tradition began on December 31, 1862, when blacks gathered in churches and homes to await news that the Emancipation Proclamation had indeed become law. This original Watch Night, according to these accounts, was also known as Freedom's Eve. Contemporary Watch Night services commemorate the liberation of all slaves in the Confederate states, which occurred on January 1, 1863.

There is another explanation of the Watch Night service. It is said that slaves in the Old South would gather in desperation on the last night of the year to await news regarding which of them would be sold on New Year's Day to satisfy their masters' outstanding debts.

Scholars today generally believe that both explanations are in error. Slaveholders who had incurred debt would have no reason to wait for January 1 to sell slaves in order to pay off creditors. Slaves were no different than any other property in that earlier America and could be sold whenever their masters found themselves strapped for cash.

The Freedom's Eve explanation for the origin of Watch Night is engaging, to be sure, but not historically accurate. The practice actually began with the Moravians, a small Christian denomination, in Europe. Scholars believe that the first Watch Night service was held in 1733 on the estate of a German count.

John Wesley, the founder of Methodism, incorporated the Watch Night service into his denomination, where it took root. These early Watch Night services were not New Year's Eve events, however. They were held once a month and on full moons. The first Watch Night service in the United States was held in 1770 at Old St. George's Church in Philadelphia.

Obviously, Watch Night had nothing to do with slavery. The object of the service was to provide the members of the congregation with an opportunity to reflect on their relationship with God and ponder whether they, as good Christians, were ready to meet their Maker if their lives suddenly were to end. In this respect, Watch Night is rooted in the scriptural passage: "Watch ye therefore: for ye know not when the master of the house cometh, at even, or at midnight, or at the cockcrowing, or in the morning: Lest coming suddenly he find you sleeping. And what I say unto you and I say unto all, Watch." Mark 13:35–37.

We may safely assume that the congregations of the Brooklyn and Rocky Fork churches, as members of the African Methodist Episcopal denomination, were familiar with the Watch Night practice and observed it. We may also assume that all African Americans eagerly anticipated midnight on New Year's Eve 1862. At that hour, the Emancipation Proclamation took effect and liberated all slaves held in the Confederate states.

# New Year's

I have yet to find any written account of 1862 New Year's Eve Watch Night in southern Illinois, but we can garner some idea of that emotionally charged night by reading Frederick Douglass's description. The site is Boston, where abolitionist sentiment ran strong:

> *Eight, nine, ten o'clock came and went, and still no word. A visible shadow seemed falling on the expecting throng, which the confident utterances of the speakers sought in vain to dispel. At last, when patience was well-nigh exhausted, and suspense was becoming agony, a man (I think it was judge Russell) with hasty step advanced through the crowd, and with a face fairly illuminated with the news he bore, exclaimed in tones that thrilled all hearts, "It is coming! It is on the wires!!" The effect of this announcement was startling beyond description, and the scene was wild and grand. Joy and gladness exhausted all forms of expression, from shouts and praise to sobs and tears. My old friend Rue, a colored preacher, a man of wonderful vocal power, expressed the heartfelt emotion of the hour, when he led all voices in the anthem, "Sound the loud timbrel o'er Egypt's dark sea, Jehovah hath triumphed, his people are free."*
>
> *About twelve o'clock, seeing there was no disposition to retire from the hall, which must be vacated, my friend Grimes (of blessed memory), rose and moved that the meeting adjourn to the Twelfth Baptist Church, of which he was pastor, and soon the church was packed from doors to pulpit, and this meeting did not break up till near dawn of day. It was one of the most affecting and thrilling occasions I ever witnessed, and a worthy celebration of the first step on the part of the nation in its departure from the thraldom of ages.*

No one can doubt that the congregations of Brooklyn, Rocky Fork and every other African American church in southern Illinois and the entire United States rejoiced in this fashion upon learning that the promise of the Emancipation Proclamation had been realized. While the New Year's Eve Watch Night tradition had not been born on January 1, 1863, it henceforth acquired an added significance that Wesley or even the Moravians could never have foreseen.

# The Twelve Bells
# of Belleville

The ringing of church bells at midnight on New Year's Eve as a custom in southern Illinois grew with the increase in this region's population. The earliest settlements had no churches. When an area's inhabitants felt the need for a house of worship, someone's cabin had to suffice for a Sunday service. The first buildings that were specifically constructed for use as churches had neither steeples nor bells. As a rule, bells could not be produced locally and were difficult to obtain. The cost of such an item often proved prohibitive for cash-strapped pioneer communities, while transporting a heavy, cumbersome bell over primitive roads and paths was an ordeal.

A southern Illinois church with a bell indicated that a settlement had attained a significant degree of population and prosperity. When that community acquired a second church that also possessed a bell, it meant that settlement was now a bona fide town. A town with three churches, all of which had bells, could be designated without fear of pretentiousness as a city.

Belleville in 1895 had no fewer than six churches with a total of twelve bells, which meant that it was one of the leading cities in southern Illinois. It also meant that the seat of St. Clair County resounded with joyous peals at midnight on New Year's Eve of that year. The late Emilie Heber, a retired public schoolteacher in that city, recalled that night from her childhood and left us a delightful account.

It was so bitterly cold, she wrote, that no one in Belleville was walking about, except policemen patrolling their beats. No sleighs coursed over the snow-covered streets. In the silence of that long-ago night, Emilie Heber and her family awaited the ringing of church bells to herald the new year.

Henry F. Heber, Emilie Heber's father, was a German immigrant who had loved the church bells of the old country, especially those of the Cologne Cathedral. He imparted this love of bells to his family, and listening to the ringing bells on New Year's Eve was a cherished family tradition. Whoever was first awakened by the midnight bells would wake the other family members so that all could enjoy those beautiful sounds. New Year's Eve 1895, however, was so cold that the family had no desire to leave the warmth of their feather beds and blankets. It was agreed that the transoms over their bedroom doors would be left open slightly to carry their voices. The one who first heard the bells would call to the others.

Margaretha Jung Heber, Emilie's mother, was a light sleeper and readily awakened with the first ringing. She called out to the others. Emilie Heber wrote, "We lay snug and warm under the big feather-beds and listened. We even untied the strings of our night-caps in order to hear better."

Emilie Heber's memory was such that she recalled not only the names of the six Belleville churches whose bells pealed out that night but even how many bells each church contained. She listed them as: the German Methodist Church on South Jackson Street, two bells; the English Methodist Church on East Washington, two bells; Zion Lutheran Church, two bells; St. Luke's Church on the corner of Church and C Streets, two bells; St. Paul's Evangelical Church on West B Street, two bells; and St. Peter's Cathedral on the corner of South Third and Harrison Streets, two bells. When the ringing ceased, the Heber family wished each other *"ein glueckliches Neujahr"* (a Happy New Year) and drifted off to sleep.

The Hebers eagerly anticipated listening to the bells on each New Year's Eve, but the growth of loud revelry in Belleville on the last day of the year eventually interfered with this custom. She wrote

that "amid all the noise of later New Year's nights we were able to hear the bells of just two churches." The others presumably were drowned out by shouts, fireworks and weapons discharged by festive crowds of merrymakers. Belleville had entered the modern age.

# "La Guiannée"

The pioneer French in southern Illinois had their own New Year's Eve customs. Their festivities began with the singing of "La Guiannée."

Historians believe that "La Guiannée" originated in sixteenth-century France. Peasants went to the homes of the wealthy on New Year's Eve and sang a multiverse song known as "La Guiannée" to wish them health and good fortune. The singers then requested food from their audience.

French soldiers and settlers brought "La Guiannée" with them to the New World. Soldiers at Fort de Chartres, founded in 1720, and residents of the nearby village of Prairie du Rocher, which was founded two years later, sang "La Guiannée" on New Year's Eve. The La Guiannée Society of Prairie du Rocher proudly notes that "La Guiannée" has been performed every New Year's Eve since the founding of Fort de Chartres. It is one of the oldest continuing traditions of celebration in the United States.

The forty or so members of the La Guiannée Society gather at Prairie du Rocher's American Legion Hall on New Year's Eve. Society members include men and women, adults and teenagers. All wear eighteenth-century costumes. At least eight members are accomplished fiddlers.

Members of the La Guiannée Society of Prairie du Rocher include musicians and singers in period costumes.

The first stop on the evening's itinerary is the reconstructed Fort de Chartres. Then it's on to the Creole House, which dates to the eighteenth century. The revelers sing to patrons of two local taverns before visiting the homes of local residents.

They sing all seventeen verses of "La Guiannée" in French. The song begins with a greeting to the home's residents and expresses the hope that they are well and happy. Succeeding verses request some pork that the singers will make into sausage. After a few verses that celebrate the beauty of nature, "La Guiannée" concludes with a request that the family allow the eldest daughter to leave the house and accompany the singers. The revelers promise to take good care of her and "keep her feet warm."

"La Guiannée" no longer is sung in France, although it survives in French-speaking Quebec. The La Guiannée Society of Prairie du Rocher makes certain that this tradition continues to enrich the cultural life of southern Illinois.

In olden days, our region's deeply religious French always attended Mass on New Year's Day, which they knew as *Le Jour de L'An*. The

"La Guiannée" has been performed continuously in Prairie du Rocher since 1720. It is one of the oldest continuing traditions in the United States.

morning was devoted to visiting the home of the family patriarch and matriarch. Adults, their children and even their children's children would each kneel in turn before the elderly couple and request their blessing as they wished them a Happy New Year, good health and heaven at the end of their days. It was also on *Le Jour de L'An*, rather than *Noël*, that children received *étrennes* (gifts) from their extended family. As each relative was visited, the children would be given more *étrennes* until their little arms were filled.

Writing about New Year's in St. Louis, another old French community, Harnett Kane noted that residents traditionally regarded the day as a time of reconciliation. Rifts were closed and disputes were resolved by those who had been at odds. When calling on friends, one always wished them a Happy New Year and asked forgiveness for any wrongs one might have committed against them during the past year. A handshake or embrace invariably followed.

Imagine beginning the new year with every broken friendship mended and a heartfelt reconciliation achieved with every estranged

relative. Now for the *real* stretch: imagine yourself demonstrating the kind of moral courage that would enable you not merely to accept such overtures but to offer them to others as well.

Perhaps modern southern Illinoisans and every resident of Planet Earth should seriously consider adopting this particular old French custom. Our lives could only be enriched by it.

# Twelfth Night

# Wise Men and Chalk Marks

Twelfth Night is the traditional name for January 6, which is the twelfth day after New Christmas. Many Christians celebrate Twelfth Night as the Feast of the Epiphany, when the magi finally reached Jesus after their long journey. In centuries past, however, Twelfth Night was defined as the evening of January 5, with January 6 known as Twelfth Day. It marked the official end of the Christmas season and all its attendant revelry. Most southern Illinoisans of my acquaintance regard the evening of January 6 as Twelfth Night and celebrate it as such—if, indeed, they celebrate Twelfth Night at all.

As far as festivities and folklore in our region go, Twelfth Night is quite the poor cousin to Christmas and New Year's. Many residents are totally unfamiliar with it. My family's Yuletide decorations, except for the Nativity set, were long gone by Epiphany. Every January 6, my mother finally placed the figures of the three kings, bearing their gifts of gold, frankincense and myrrh, alongside the shepherds who knelt in adoration of the infant Jesus. Mother, fastidious as ever, always remarked that many families placed the wise men by Jesus' crib when they set up their Nativity sets in early December. Well, not in *our* house, she noted. Epiphany—she never called it Twelfth Night— marked the arrival of the three kings, so our figures could just cool their heels until the proper time for their display rolled around.

The wise men's annual appearance marked the extent of the Twelfth Night celebration in my household. Uncle Joe's Irish ancestors evidently had not made much of the day either, so I never heard a Twelfth Night tale from him. The Nativity set stayed in place for a few more days so the wise men could pay their due respect to the divine infant. Then, all the figures, as well as the wooden stable, were wrapped in newspapers, boxed up and carried to the attic.

While my wife and I display that same Nativity set each Christmas, my mother would be horrified to learn that we have joined those families that place the wise men near Jesus' crib in December. It simply wouldn't do to make these kings wait for January 6 to make their annual appearance, since we box up *all* the figures on January 2 or so. I like to think that mom would take some comfort from the knowledge that her son observes Twelfth Night to a degree that would have been almost unimaginable to my family.

While not part of my family's holiday traditions, chalking the door was a Twelfth Night custom that almost certainly was observed in southern Illinois. I write "almost" because I haven't yet talked with anyone whose family practices or formerly practiced this rite. Still, chalking the door formerly was widely observed in Britain, and there is every reason to believe that the custom crossed the Atlantic with immigrants and took root in American soil.

Chalking the door was simple yet heartfelt. On Twelfth Night, the head of the household used chalk to draw sacred symbols, such as a cross, on the upper horizontal piece of a home's main doorway. Since Twelfth Night, or Epiphany, celebrates the magi finally discovering the dwelling place of the Christ Child, some observants of chalking the door wrote the letters CMB, which stood for the names that were traditionally ascribed to the three kings: Caspar, Melchior and Balthazar. Other families wrote the letters CMB but considered them an abbreviation for the Latin phrase "*Christus Mansionem Benedicat*," which translates as "May Christ bless this dwelling."

Although the origins of the custom remain obscure, scholars have noted the similarity between chalking the door and the Exodus account of the Hebrews marking their doors with lamb's blood so that they would be spared when all of Egypt's firstborn were slain.

Observants of chalking the door, however, noted that this custom asked God to bless their households rather than save them from an impending calamity.

While chalking the door generally is no longer practiced, the United Methodist Church is attempting to revive the custom and even offers a suggested liturgy that is available online for families that would like to add it to their holiday observances. In order to make chalking the door more inclusive, this denomination suggests that children and wheelchair users who wish to participate in the custom place symbols or words anywhere on the doorframe that they can comfortably reach.

# The Three Kings of Germantown

As the name of this southern Illinois town suggests, a large number of German immigrants settled here and brought some Old World customs with them—including a unique Epiphany celebration that features residents dressed as *die drei könige,* or the three kings. The kings are accompanied by two attendants, who are also in costume, as well as two Germantown residents in the attire of clowns. All participants are members of the choir at St. Boniface Catholic Church in Germantown.

One person carries a brightly decorated star on a short pole that represents the star of Bethlehem. The star is turned to symbolize the journey of the three kings and stops when they reach Jerusalem. Members of the party sing an old ballad with German lyrics that tell the story of Epiphany. The song begins with the party proclaiming, "Here we are with our star; we are looking for the Lord. We very much want to see him."

After their encounter with Herod, the lyrics accuse the evil monarch of speaking with "a false heart," since Matthew's gospel portrays Herod as asking the kings to return after finding the Christ Child so that he might learn the Babe's location and worship him as well. His true intention, of course, was to kill him. The one holding the star begins turning it again, stopping the star when the song's lyrics indicate the party has reached Bethlehem and found the Christ Child. "Now the three of us fall on our knees and offer our gifts to the little child."

At this point, the troupe performs a parody of the visit that they sing in the style of the Litany of the Saints, a Roman Catholic prayer-chant. The parody tells of three men on a journey. They reach a great sea, only to discover that their boats leak. The trio then goes to a church, where they encounter a pastor with a crabby housekeeper. This bizarre parody is led by the clowns, with other members of the troupe serving as the choir. The meaning and origin of this parody, as well as its relevance to Epiphany, are unclear.

The tradition now concludes with the troupe singing in German, "In joy and in unity, may God give you heavenly joy" and wishing the listeners a happy new year.

In years past, a company of singers performed the song while visiting the homes of Germantown residents. Volunteers from St. Boniface now present this tradition for residents of nursing homes in Clinton County.

Germantown residents note that nearby Teutopolis, Illinois, was also heavily settled by German immigrants. Townspeople of that community performed *die drei könige* on Epiphany until quite recently. Sparked by the enthusiasm of the volunteers from St. Boniface Church, *die drei konige* should thrive in Germantown for many years to come.

# Bal des Rois

Alton has two Twelfth Night festivals, one in the Christian Hill district's Riverview Park and the other in the Middletown area's Haskell Park. The Christmas trees of neighborhood residents are piled high and then ignited—under the watchful eye of the Alton Fire Department, of course.

Why burn Christmas trees on Twelfth Night? The most popular explanation is that the blaze of burning evergreens symbolizes the star that guided the wise men to Jesus. The Haskell Park festival, which my wife and I attend, features the arrival of three men costumed as the magi, whose appearance is heralded by the singing of "We Three Kings." The identity of the men is supposed to be a well-guarded secret, although I was able to ascertain one king's identity when he spoke to Loretta and me. The men who play the magi are area residents who are working to better our community and are chosen to be "kings for an evening" as a way of honoring them for their contributions to Alton. Light snacks are served, while coffee and wassail help to counter the chilly night air.

The Riverview Park event is decades old, while the Haskell Park festival is a more recent affair. Mary Esther Cousley, a resident of Christian Hill and a member of the family that for many years owned Alton's only newspaper, invited some neighbors to burn their Christmas trees on January 6, 1943, in the incinerator behind their home on Belleview Street. From that humble beginning grew

# Twelfth Night

A giant bonfire of Christmas trees at the Twelfth Night festival in Alton.

The three kings traditionally make an appearance at the Twelfth Night tree burning at Alton's Haskell Park.

one of Alton's most beloved holiday traditions. As the numbers of trees to be burned increased, the burning shifted from the Cousley incinerator to Riverview Park.

Cousley was killed in an automobile accident in 1965. The tradition continued for a few more Twelfth Nights but, without its founder's participation, gradually lost popularity and was discontinued. It was reestablished in 1980 and enjoys an even greater level of popularity than it knew in Cousley's day.

Both of Alton's tree-burning events are eminently enjoyable yet relatively modest as far as Twelfth Night parties go. For a truly rollicking celebration, we must turn to the French pioneers of southern Illinois.

The French cherished Twelfth Night, which they knew as *le Jour des Rois* (Day of the Kings). Fervent Catholics, they always attended a Mass on *le Jour des Rois*. The evening, however, was devoted to the *Bal des Rois* (Kings' Ball), a gala dance steeped in tradition.

Revelers at the tree-burning festival sing "We Three Kings" as it begins to snow.

# Twelfth Night

In addition to candles and lanterns, some Kings' Balls were illuminated by thirteen fires that signified Jesus and his apostles. The largest of these fires symbolized Christ, "the light of the world," while the smallest represented Judas. At the ball's conclusion, revelers stamped out the "Judas fire" to express their contempt for the betrayer of Jesus.

Whether held in a grand hall or private home, all Kings' Balls featured a *Galette des Rois* (Kings' Cake). Described by one historian as a slightly sweetened bread with a taste like brioche, the Kings' Cake was always cut so that there would be one slice more than the number of guests. This extra slice, known as *la part à Dieu* (God's slice), was given to the first poor person who came to the door seeking food.

Excitement grew as slices of the Kings' Cake were distributed to revelers. A bean had been baked into the cake, and the man whose slice contained it became the king of the Twelfth Night ball! The king chose a queen, and the two reigned as royalty for an evening. When the king lifted his glass to drink, his "court" of partygoers cried out in facetious tribute, "The king drinks!"

Tiny figures, such as these, represent the infant Jesus and are baked into Kings' Cakes for Twelfth Night.

Loretta Dunphy, the author's wife, baked these two Kings' Cakes for a children's Twelfth Night festival at Main Street United Methodist Church in Alton.

Kings' Cakes are available today in many bakeries and supermarkets, although the tradition has been commercialized almost beyond recognition. No longer limited to Twelfth Night, Kings' Cakes are offered for sale shortly after New Year's Day and can still be purchased as late as Fat Tuesday, better known as Mardi Gras. Since the time for Kings' Cakes has become the entire Mardi Gras season, they are adorned with sprinkles in the traditional colors of that festival: green, yellow and purple. Some bakeries also decorate their cakes with red to symbolize the life of Christ. The cakes are oval-shaped to signify the unity of all Christians.

The ingredients of a Kings' Cake can be said to have undergone nothing less than a revolution since the time of the French pioneers. The slightly sweetened bread with a brioche-like taste is now a sticky, gooey coffeecake. The lowly bean has been replaced by a tiny plastic figure of a baby that represents the infant Jesus. One places this figure within the Kings' Cake so that those who partake of its slices are said to emulate the search of the magi for the Bethlehem Babe. Custom dictates that the one

This happy little boy found the infant Jesus in his slice of a Kings' Cake baked by Loretta.

whose slice contains the baby must bring a Kings' Cake to next year's gathering.

I've enjoyed a slice or two of these revisionist Kings' Cakes with friends, although I would hardly call any of the modest gatherings a Kings' Ball. For a true *Bal des Rois*, one must journey to the old French Colonial District of southern Illinois.

Each year, on Twelfth Night or the Saturday following Twelfth Night, reenactors stage a thoroughly delightful *Bal des Rois* in Prairie du Rocher's American Legion Hall. To enter the ballroom is to step back into the eighteenth century. The electric lights are muted so that the room appears to be illuminated primarily by the candles on revelers' tables. Everyone, including children, is dressed in colonial garb. Some of the reenactors are so meticulous about period detail that even their eyeglasses sport the small, round or rectangular lenses of an earlier era.

The music is superb. While the performers use microphones so that the songs can be heard throughout the ballroom, their instruments are acoustic. The dances, like the band's songs, belong to an earlier

*Above*: Dancers go under the arch at Prairie du Rocher's *Bal des Rois*.

*Left*: The making of a huge Kings' Cake at the Kings' Ball. Several beans have been baked inside the cake.

America and can pose a challenge for *Bal des Rois* newcomers. Many novices receive impromptu dance coaching by sympathetic participants but enjoy the ball as much as veteran reenactors.

The easiest dance—and probably the most fun—is the paddle dance. No, it isn't performed in some grizzled reenactor's canoe. Men and women form two lines opposite each other, with the person at the beginning of each line holding a paddle. This paddle holder is flanked by two women. He then has the option of deciding which woman he wishes for a dancing partner. The lucky man chooses a woman, hands the paddle to the woman he decided against and then dances with his partner down the narrow aisle that exists between the lines of men and women. The woman holding the paddle is immediately flanked by two men. Now *she* has the option of choosing a dance partner. The man left holding the paddle is promptly flanked by the next two women from the women's line, and the dance continues.

The highlight of *Bal des Rois* is the selection of the king and queen. To make things even more lively, four beans have been baked into the Kings' Cake. The first man to discover a bean in his cake slice

Lining up for refreshments at the *Bal des Rois*.

The king and queen are surrounded by their court of runners-up and two little girls who serve as pages.

becomes king and chooses a queen. The next three men to find beans are runners-up and select ladies, who also become members of this royal court. While it isn't required that a married bean-finder choose his wife as partner, it is customary—not to mention judicious. I experienced beginner's luck at my first *Bal des Rois* in 1998 and was the second man to find a bean in my slice of Kings' Cake, which, by the way, tasted like a delicious, home-baked pound cake.

The king and queen, escorted by two adorable little girls who serve as pages, promenade to their thrones, which are ordinary chairs made regal with a bit of imaginative decorating. The revelers applaud the duo as they walk down the aisle. The runners-up follow in order and assume places of honor next to the royal couple.

I've attended other Kings' Balls but have yet to find another bean in my cake slice. No matter, though; I will treasure the memory of that 1998 *Bal des Rois* forever.

The Kings' Ball in Prairie du Rocher concludes the celebration of Twelfth Night in southern Illinois, formally bringing our region's Christmas season to an end. The French Colonial District keeps

Everyone joins in the fun at the Kings' Ball.

the Gallic spirit alive beyond January 6, of course. Reenactors host a rollicking Mardi Gras dance at Cahokia's Knights of Columbus Hall on the Saturday before Fat Tuesday. But Mardi Gras, Lent and Easter in southern Illinois comprise another story and deserve a book of their own.

# Bibliography

## ARTICLES BY THE AUTHOR THAT DEAL WITH CHRISTMAS

"A Candle for a Priest." *St. Louis Post-Dispatch*, December 25, 2001.

"Christmas Folklore Teaches Us Much" [Alton, IL]. *Telegraph*, December 22, 1996.

"Christmas Lily Tradition Endures at Illinois Church." *St. Louis Post-Dispatch*, December 25, 2006.

"The Christmas Rose," *Springhouse* 8, no. 6 (December 1991).

"Have You Ever Heard of 'Old Christmas'?" *Country* (January 1998).

"The Legend of the Poinsettia." *Illinois Magazine* (November–December 1984).

"The Lingering Tradition of Old Christmas." *St. Louis Post-Dispatch*, December 25, 1996.

"Old Christmas." *Country Living* (December 1994).

"Picturing a Miracle." *St. Louis Post-Dispatch*, December 25, 2003.

"Pioneer Christmas in Southern Illinois." *Springhouse* 1, no. 7 (November–December 1984).

"A Rose Blooms at Christmas in Illinois." *St. Louis Post-Dispatch*, December 25, 1993.

"A Tradition of Light, for Luck and Memory." *St. Louis Post-Dispatch*, December 25, 2005.

## ARTICLES BY THE AUTHOR
## THAT DEAL WITH NEW YEAR'S

"An Illinois Town Marks Our French Heritage with a Song." *St. Louis Post-Dispatch*, December 31, 2007.

"New Year's: A Time for Reconciliation." *St. Louis Post-Dispatch*, December 31, 1998.

"New Year's in Old Southern Illinois." *Springhouse* 5, no. 6 (December 1988).

"Old-Time New Year's Traditions." *Country Living* (December 1995).

"Starting Off On the Right Foot." *St. Louis Post-Dispatch*, January 1, 1995.

## ARTICLES BY THE AUTHOR
## THAT DEAL WITH TWELFTH NIGHT

"A (Cake) Slice of History: The Man who Would Be King." *St. Louis Post-Dispatch*, January 5, 2001.

"Kings' Cakes: An Old French Tradition." *Springhouse* 12, no. 6 (December 1995).

"Twelfth Night in Prairie du Rocher." *Springhouse* 15, no. 6 (December 1998).

"A Twelfth Night Tale of Old Cahokia." *Springhouse* 11, no. 6 (December 1994).

## WORKS THAT WERE USEFUL
## IN THE AUTHOR'S RESEARCH

Allen, John W. *Legends and Lore of Southern Illinois*. Johnson City, IL: A.E.R.P., 1985.

*Alton* [IL] *Evening Telegraph*. "Letter in Yule Tree from Boy on Canadian Farm," December 23, 1958.

Andrews, Peter, ed. *Christmas in Germany*. Chicago: World Book, 1974.

Auld, William Muir. *Christmas Traditions*. New York: Macmillan, 1931.

Bister, Ada Klett. "Christmas with the Engelmann Family." *American German Review* (December 1950).

Bzrueggmann, Brian. "German Tradition Being Kept Alive." *Centralia* [IL] *Sentinel*, January 8, 1996.

Casey, John. "The Twelfth Night Burning of the Trees on Christian Hill." http://riverviewpark.tripod.com/id48.html.

Cha-Jua, Sundiata Keita. *America's First Black Town: Brooklyn, Illinois, 1830–1915*. Urbana and Chicago: University of Illinois Press, 2000.

Coffin, Tristram. *The Book of Christmas Folklore*. New York: Seabury Press, 1973.

Crump, William D. *The Christmas Encyclopedia*. 2nd ed. Jefferson, NC, and London: McFarland & Company, Inc., 2006.

Devenport, Vickie. "African American Settlements in Southern Illinois." Undated pamphlet published by U.S. Forest Service/Shawnee National Forest and General John A. Logan Museum.

Douglass, Frederick. *My Bondage and My Freedom*. New York: Miller, Orton and Mulligan, 1857.

———. *My Bondage and My Freedom*. Hartford, CT: Park Publishing, 1882.

Dunphy, John J., and Susan Dunphy. *Lewis and Clark's Illinois Volunteers*. Alton, IL: Second Reading Publications, 2003.

Engles, Stephen E., and Theresa Rice Engels, eds. *An Illinois Christmas Anthology*. St. Cloud, MN: Partridge Press, 1991.

Floyd, Don. "Christmas Memories." *Springhouse* 24, no. 6.

Heber, Emilie P. "When Belleville's Bells Heralded the New Year." *Belleville* [IL] *News-Democrat*, n.d.

Helton, Roy. *Lonesome Water*. New York: Harper and Brothers, 1930.

Hoffman, Judy. *God's Portion: Godfrey, Illinois 1817–1865*. Nashville, TN: Cold Tree Press, 2005.

Irving, Washington. *The Sketch Book of Geoffrey Crayon, Gent*. Chicago, New York, San Francisco: Belford, Clarke and Company, 1889.

Jones, Charles. "Knickerbocker Santa Claus." *New York Historical Society Quarterly* 38 (1954).

Jones, Landon Y. *The Essential Lewis and Clark*. New York: Echo Press, 2000.

Kane, Hanett T. *The Southern Christmas Book*. New York: David McKay, 1958.

McDermott, John Francis. *Old Cahokia: A Narrative and Documents Illustrating the First Century of its History*. St. Louis, MO: St. Louis Historical Documents Foundation, 1949.

Miles, Clement A. *Christmas in Ritual and Tradition*. London: T. Fisher Unwin, 1912.

Miller, Olive Beaupre. *Heroes, Outlaws & Funny Fellows of American Popular Tales*. New York: Doubleday, Doran and Company, 1942.

Morwood, Burton Westlake. "A Modern Saga of an Old-Time Upper Alton Home." Unpublished manuscript, dated April 9, 1971, in the library of the author.

Nissenbaum, Stephen. *The Battle for Christmas*. New York: Vintage Books, 1997.

Pruett, Gordon. "Books Published by Hal W. Trovillion." *Springhouse* 8, no. 2 (April 1991).

Randolph, Vance. *Ozark Magic and Folklore*. New York: Dover, 1964.

Roth, Susie Hurford. "Christmas in 1964." Unpublished essay sent to the author.

Schori, Ward. "I Remember Hal Trovillion." *Springhouse* 8, no. 2 (April 1991).

Spicer, Dorothy Gladys. *Festivals of Western Europe*. New York: H.W. Wilson, 1961.

Suess, Adolph B., ed. *The Romantic Story of Old Cahokia, Illinois*. Belleville, IL: Buechler Publishing Company.

Trovillion, Hal W., and Violet Trovillion. *Christmas at Thatchcot*. Herrin, IL: Trovillion Private Press at the Sign of the Silver Horse, 1947.

Untermeyer, Louis, ed. *The Book of Living Verse*. New York: Harcourt, Brace and Company, Inc., 1939.

# About the Author

B orn in Alton, Illinois, and now residing in the village of Godfrey, John J. Dunphy is a summa cum laude graduate of Southern Illinois University at Edwardsville and attended that university's graduate school on an academic fellowship. He is a member of the SIUE School of Education's Academy of Fellows and also serves on the Executive Advisory Board of the SIUE School of Education.

Dunphy has written hundreds of articles for magazines and newspapers. His books include *Lewis and Clark's Illinois Volunteers, It Happened at the River Bend* and *Dark Nebulae*, as well as several chapbooks of haiku poetry. He taught writing at Lewis and Clark Community College for almost a decade and owns the Second Reading Book Shop in Alton, Illinois. Visit him in cyberspace at www.johndunphy.com and www.secondreadingbookshop.com.

Please visit us at
www.historypress.net